LEARNING TO LIGHT

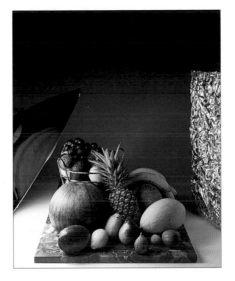

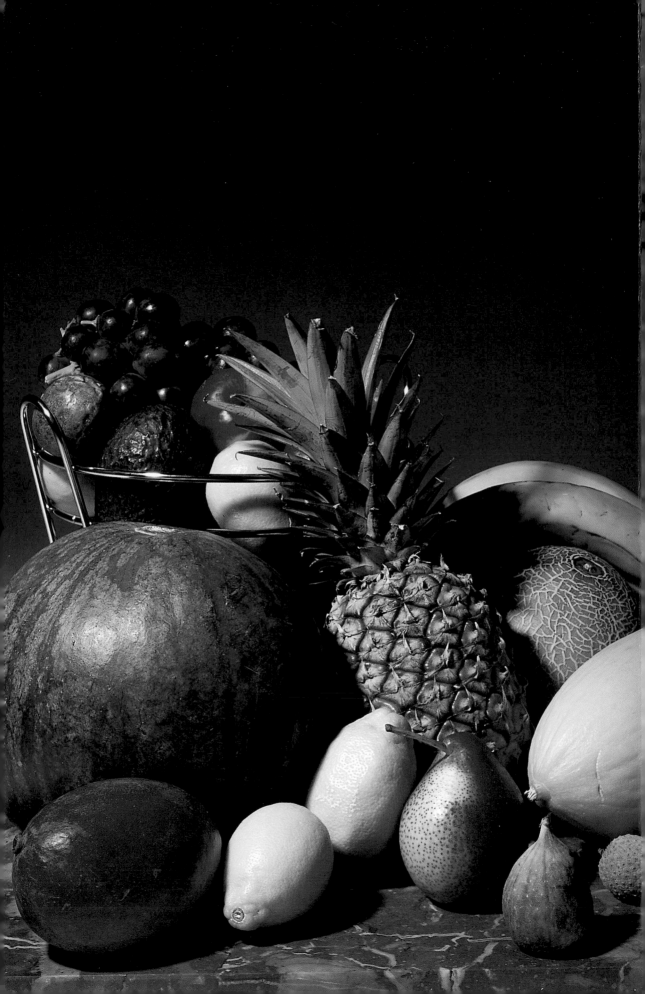

LEARNING TO LIGHT
Easy and Affordable Techniques for the Photographer

Roger Hicks & Frances Schultz

Amphoto Books
An imprint of Watson-Guptill Publications/New York

First published in the United States by Amphoto Books
An imprint of Watson-Guptill Publications, Nielsen Business Media,
A division of The Nielsen Company
770 Broadway, New York, NY 10003
www.watsonguptill.com

First published in the United Kingdom in 1998 by
Collins & Brown
10 Southcombe Street, London, W14 0RA
An imprint of Anova Books Company Ltd

Hicks, Roger (Roger William)
Learning to Light: Easy and affordable techniques for the photographer /
Roger Hicks and Frances Schultz
p. cm.
Includes Index.
ISBN-10: 0-8174-4179-4 (pbk.)
ISBN-13: 978-0-8174-4179-1
1. Photography - Lighting I. Schultz, Frances E. II. Title.
TR590.H5297 1998
778.7'2-dc21

Conceived, edited and designed by Collins & Brown

Editorial Director: Sarah Hoggett
Art Director: Roger Bristow
Editor: Robin Gurdon
Designed by: Steve Wooster
Designers: Charlie Darling, Alison Lee
Cover photograph: Mike Newton

Printed and bound by Craft Print International Ltd, Singapore

Contents

Introduction

LIGHTING IS AN area of photography that intimidates many people. The two most common preconceptions are that it's expensive, and that it's difficult. Neither, fortunately, is particularly true.

You can, of course, spend a great deal of money on lights, but compared with what many people spend on cameras and lenses, the cost of lighting equipment is astonishingly modest. Its usefulness will also extend across the range of your photography unlike any other major expenditure. After all, lighting equipment opens up whole new areas of photography, in a way that merely changing your camera, or buying another lens, can never do.

For the price of a good 35mm SLR body or a high-specification zoom, you can buy a brand new, remarkably versatile lighting outfit. For a lot less than that – about the price of ten rolls of process-paid color slide film – you can put together a lighting outfit that will allow you to learn the rudiments of lighting and that will, in all probability, spur you on to invest in something more sophisticated. On pages 154–155 there are suggestions for lighting kits to suit all pockets, and throughout the book there are ideas on how to improvize and to save money.

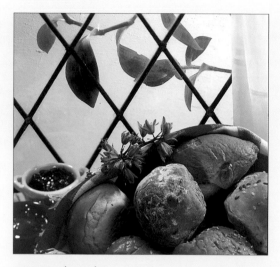

Morning (ABOVE)
Cold light on a rough-cast wall, the sun through the kitchen window, early morning… Not a bit of it! The "kitchen window" is a panel from a kitchen cabinet; the "wall" is plywood painted with emulsion mixed with sawdust; the "sunlight" is a flash head with snooted spot (page 62), warmed up with a Light Stuff #10 yellow filter; the light on the wall "outside" is from another flash head, with a honeycomb; a third flash head, in a soft box (page 64), provides a little "fill" to lighten the shadowed side of the rolls.

Practice makes perfect

Unless you have access to lighting equipment, you can't learn to light. Even if you join a photography club where lighting is demonstrated, or take part in lighting workshops and masterclasses, you will see only a limited range of lighting set-ups for particular subjects. What you won't see on these occasions is what happens when you move this light over there, or that light up a bit, or if you try a reflector just here. You need lights of your own, and time and a roll or two of film, to learn the best way to light the subjects that interest you.

In lighting, as in any other area of photography, the sole road to improvement is practice, practice, and more practice. It is astonishing but true that someone who is prepared to spend a small fortune on upgrading their cameras or lenses will often begrudge the expense of using a whole roll of film on a single subject.

Orange (ABOVE)
With controlled light, shooting extreme close-ups is easy, rather than the lottery it can be using natural light. You don't even need very powerful lights – the flash head may only be a hand's breadth from the subject. Remember to stop down for depth of field, and overexpose to compensate for the extra extension (this lens was mounted on a bellows). This was a diffused flash of quite modest power.

Again, the photography club and the workshop spring to mind; how many people will shoot two or three frames, or at most six or eight, instead of a whole roll? And when they finally finish the roll, the lighting shots have to compete with pictures of the children playing, and shots of the castle you took them to on Sunday afternoon, and perhaps a couple of images of flowers from the garden. The lighting shots do not receive the attention they deserve, and to a very large extent, the few frames that were exposed are completely wasted, because they teach the photographer nothing.

Assuming you are willing to spend the relatively modest amount required to get into controlled lighting, and that you are prepared to invest the occasional afternoon or evening, plus a whole roll of film, on each lighting project, what else stands in the way of learning to light?

Learning the ropes

Actually, there are three potential obstacles, but all three are readily surmountable. One is the vocabulary of lighting. The second is the limits of what you can do with a given lighting outfit, and the third is having to learn the vital tricks of the trade.

The vocabulary is admittedly off-putting: "keys," "fills," "scrims," "gobos," "inkies," "flags," "bounces"; the list goes on and on. It sounds like empty jargon, and some of it is, but for the most part, lighting terminology is simply shorthand for basic tools and concepts. The strongest light, the one that determines the shadows, is the key light. You want to shade something off, so that light doesn't fall on it? Use a flag. And if you want to bounce light back onto a subject, use a bounce. As unlikely as it may seem now, by the time you have finished this book, you will be talking about "flagging the key" and "softening the fill with a scrim" as though you'd been using the terms for years.

Artichokes and asparagus (BELOW)
Broad, diffused top light emphasizes the textures and colors of the artichokes and asparagus; but it would be equally possible to make a dramatic composition in black and white with strong side-lighting, shooting the artichokes alone, or coming in close and concentrating on the asparagus. Artificial lighting gives you the opportunity to experiment in your own time in a place you can leave the shot set up, even returning on another day, if you want.

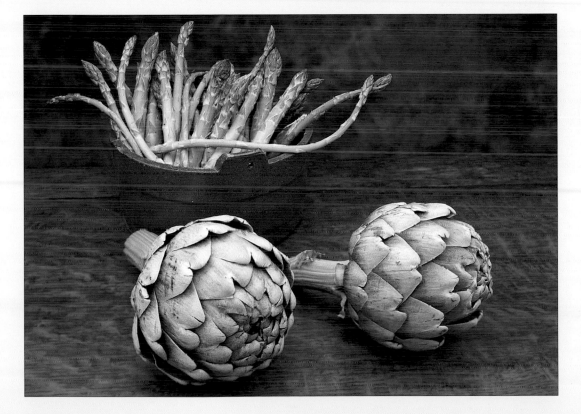

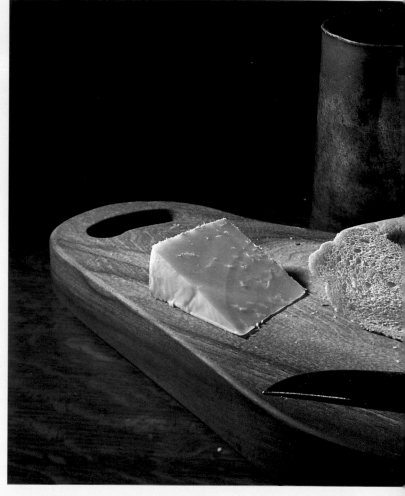

Bread and cheese
(ABOVE and RIGHT)
The great advantages of artificial lighting over natural light are that it is always available, that it is consistent, and that it is repeatable. You do not have to wait around for the right weather, and then work very quickly before the sun moves and the shadows change length and direction. You can explore different compositions, as here: the very simple original shot, with just the bread and cheese, or the more narrative shot with the knife and tankard as well. In both shots there is a single light to camera left, with a white bounce (reflector) just out of shot to camera right.

Being realistic about the limitations of your equipment may sound like an admission that lighting is expensive and difficult after all. It isn't, but there are some things, such as front projection and shadowless backgrounds, that require a bit more expenditure than simpler lighting. Often, too, there is a trade-off between time and money. Stretch a sheet of white nylon across a home-made bamboo frame; interpose that between a builder's floodlight and your subject, and you have a broad, soft light that is the equivalent of a professional's soft box, at a fraction of the price. The soft box is more convenient, of course, and you will need to decide what is best for you. Throughout the book we have tried to suggest cheaper alternatives to more expensive, professional solutions; but there are some types of pictures for which you will either have to spend the money, or invest the effort, to get the effects you want.

Tricks of the trade
As for tricks of the trade, this whole book is dedicated to these. It is, however, well worth mentioning two of the most important here. The first of these is backgrounds: with portraits, in particular, the standard professional trick is to put the background as far as is practically possible from the subject so that it can be left to go dark, or be lit independently. This removes the problem of background shadows, that often besets the amateur portrait. The second major trick is to put lights and reflectors very close to the subject: so close, in fact, that they are just outside the field of view of the camera. In photography, what you can't see doesn't hurt you. It may look as if someone's face is lit by a huge picture window 10 feet (3 meters) away, when in fact it is lit by a 3-foot (1-meter) square soft box just a hand's breadth from the edge of the picture. If you pulled the camera back a little, the illusion

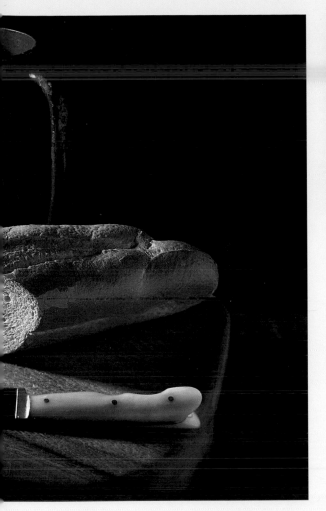

Tankard and charger (ABOVE)
In this lighting set-up the light is close to the subject, and the bounce is even closer. As long as the lights, bounces, supports, and other paraphernalia do not show in the final picture, it does not matter what is going on outside the subject area. Nor do you have to use fancy equipment like this – a white expanded polystyrene tile makes a perfect bounce to reflect light back onto the subject.

would be exposed; but you don't, so it isn't, and in photography, illusion is everything.

Subtlety through lighting
There is one more point to make before we get into the main part of the book. It is that often the photographer is striving for very subtle effects. Sometimes these effects are too subtle to be seen in normal photomechanical reproduction, as used in this book, or in a photographic magazine. They will only be visible on an original print or transparency, or in the finest art-quality reproduction on glossy, lacquered paper. To see the subtlest lighting changes in other reproductions, you need to know what to look for. These could be softer highlights in one place, more open shadows in another, or tiny differences in color saturation.

The temptation in a book or magazine article is to exaggerate these differences: instead of a subtle increase in contrast between two pictures, one is printed in shades of cigarette-ash, and the other in soot and whitewash. But photography isn't like that. Sometimes, unless you look hard, you may not see any difference between two pictures, but once you know what to look for, you can decide which effect you prefer, and you will know how to achieve it. If you can't see the difference between two illustrations on these pages, try it for yourself. On the print, or through the viewfinder, the difference should be clear. If it isn't, then it isn't important!

In other words, you should attach far less importance to the pictures in this book, whether you like them or not, than you do to your own pictures. Any photographers of worth are interested, first and foremost, in their own pictures. Anyone who isn't should be a collector, not a photographer, although you should make every effort to go to exhibitions and to see high-quality original pictures (instead of just reproductions) so that you can see the levels of quality attainable.

As we have already said, the secret of photography is practice, practice, and more practice. There is one addition to this: you'll do better if it's informed practice. If you use the information in this book as a basis, you may be surprised at how much more you get out of your photography and (dare we say it) at how accomplished a photographer you can become.

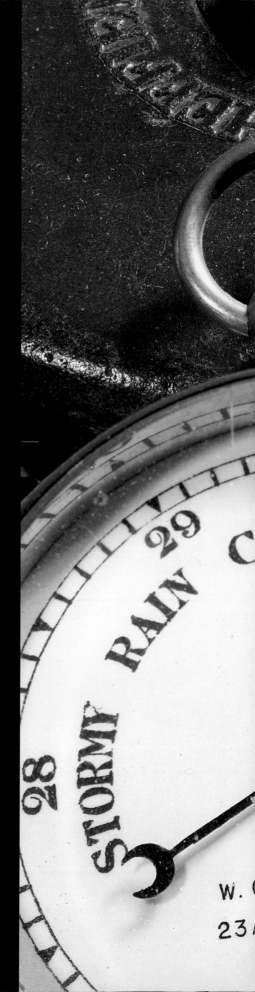

PART 1

TECHNIQUES AND EQUIPMENT

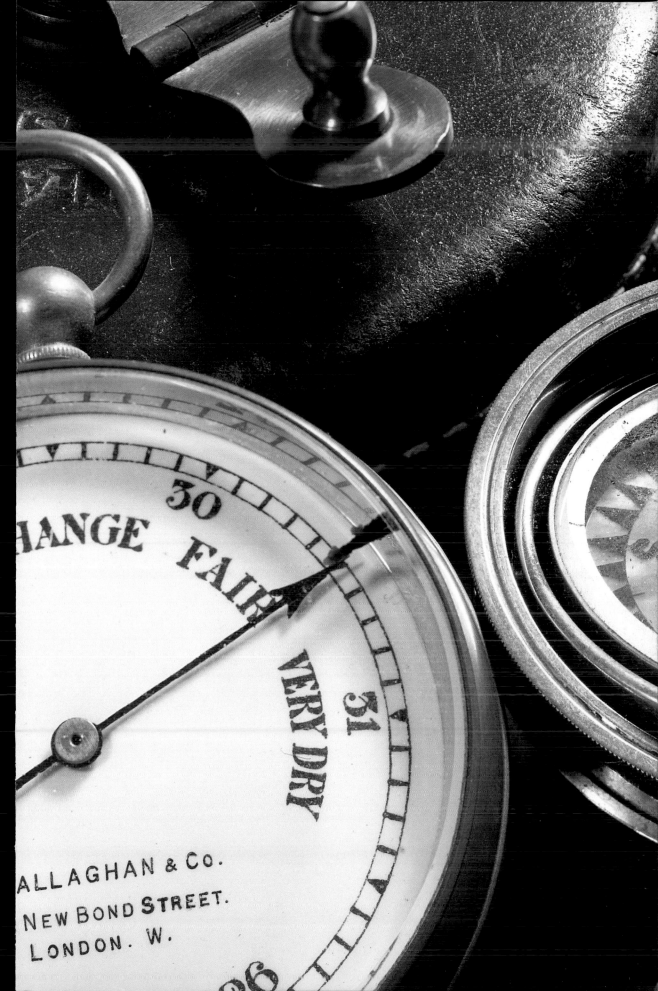

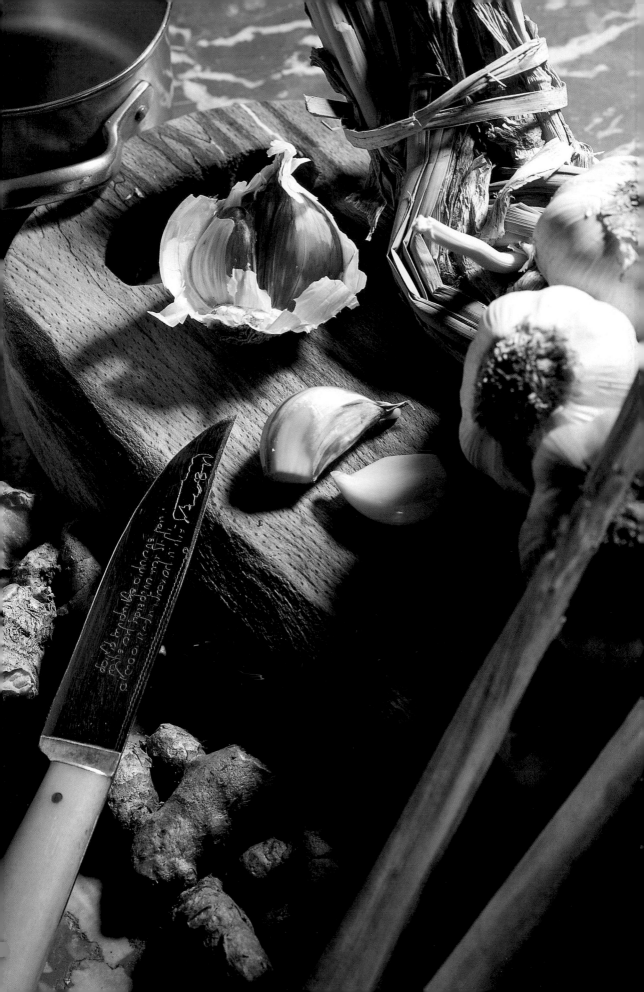

Understanding Light and Lighting

TECHNIQUES AND EQUIPMENT

Quality of Light

ALTHOUGH OFTEN USED, "quality of light" is a phrase that is almost impossible define. It is easiest to understand in terms of examples. Think of the clear light of sunrise on a cloud-free morning; or of the clarity of light after a rainstorm; or of harsh midday light; or of the light on a stormy, thundery day; or of the warm, hazy light of late afternoon and early evening. Think of the light from a window: of sunbeams slanting through it, or of the clear, shadowless light you get from a north-facing window (south-facing in the southern hemisphere).

All of these types of light and more depend on season and time of day and weather – and usually, they appear when you cannot take advantage of them. The trick in photographic lighting is to recreate the effects that you want in the studio, whether you want the warm light of sunset, the cool light of dawn, the hard-edged shadows of the desert, or the soft-edged shadows of a hazy afternoon. Essentially, this is a book about how to recreate natural lighting convincingly.

Diffuse afternoon light (BELOW)
On a wet November afternoon, the light is hazy and diffuse, and emphasizes shape rather than detail; black-and-white film drains still more energy from the bleak scene.

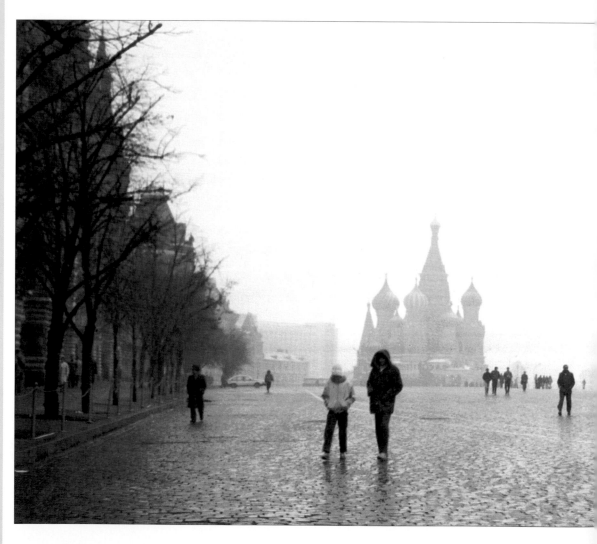

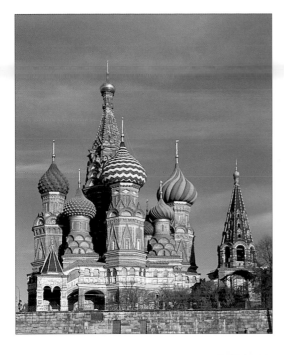

OBSERVING LIGHT

To develop an awareness of light, look at the natural world around you, at photographs, and at paintings. Ask yourself these questions:
- Where is the light coming from? (Look at the shadows.)
- Are the shadows "inky" or "open," hard-edged or soft-edged?
- Is the light warm or cool?
- Are near and distant subjects equally clear?
- How saturated are the colors?

Once you are used to analyzing light, you will find it easier to decide what to aim for in studio conditions.

Clear morning light (LEFT)

On a clear morning, the light on the famous Saint Basil's cathedral in Moscow's Red Square is warm, highly directional, and seems to pick out every detail with glowing clarity; the whole scene calls out for rich color, here achieved with underexposed ISO 50 film (Fuji RF).

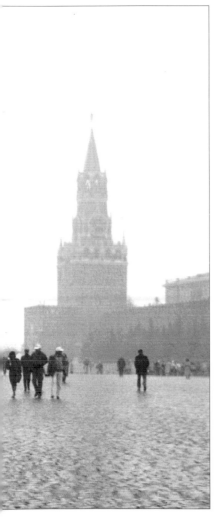

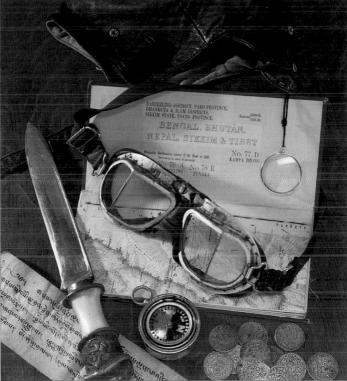

Recreating the evening sun (ABOVE)

Tungsten light on daylight film can deliver a very warm effect resembling evening sunlight. Here, a focusing spot is set low and to camera left to create slanting light and the long shadows that are typical of this time of day; the only other light is from a powerful flash unit in a soft box over the subject. By comparison with the tungsten, this looks cold, like sky light.

TECHNIQUES AND EQUIPMENT

Direction and Contrast

MILLIONS OF YEARS of evolution have conditioned us to judge all light in terms of sunlight. On a clear day, the sun is highly directional, with sharp, clear shadows. Around noon, when the sun is high in the sky, shadows are short; early or late in the day, they are longer.

On a hazy day, the light is less harsh and directional, and shadows are softer and weaker; on a totally overcast day, the light is completely diffuse, without clear shadows.

The trick in photographic lighting is to recreate such effects – and the first stage in doing this is to think about both direction and contrast. A single lightbulb, close to your subject, can create light as harsh as the midday sun, but the effect will still not be like sunlight because the shadows will not be as hard-edged, and the intensity of the light will fall off faster. A more powerful light, used from further away, will be more convincing.

Also, a photograph generally represents a scene with more contrast than appears to the naked eye. This is because the eye scans the scene, adjusting itself to suit the part under scrutiny. The camera, on the other hand, has to be set to a single aperture, which must always be a compromise. This is why you often need "fill" – a soft, supplementary light to stop the shadows looking inky and harsh.

FILM AND CONTRAST

Film is an important tool for controlling contrast. On a bright, sunny day, or where subtle tones are important, you need a soft-contrast film such as Fuji Astia; on an overcast day, when colors can look desaturated and dull, you need a contrasty film such as Fuji Velvia. In the studio, where the light is under your control, you can choose either type of film, according to the effect you want. In black and white, choose a film for its tonality and exercise restraint in changing development times to change contrast. Cutting development time too far (more than about 15 percent) can make a muddy, dull picture, while increasing it too far (more than about 50 percent) can give "soot and whitewash" contrast.

Low-contrast subjects (LEFT)
On a dull day – this is an old railway cutting in Scotland in winter – a contrasty, high-saturation film can "perk up" color and contrast; this was shot on Fuji Velvia.

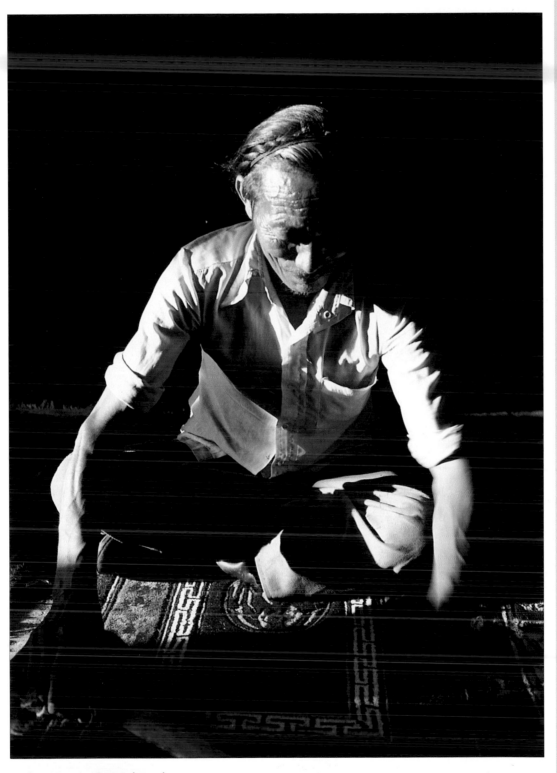

High-contrast subjects (ABOVE)

This Tibetan refugee rug-maker in Chhauntra was photographed on Kodachrome 64, once regarded as a contrasty film but now seen as fairly average. If it could be reshot, the natural choice would be a low-contrast film such as Fuji Astia, that delivers rich colors without excessive contrast. If you have a contrasty film in your camera, and you have to grab the picture, use half-stop brackets to get the best possible exposure compromise.

Color Temperature

ONE OF THE first things we learn as photographers is that tungsten light records as a very warm (and sometime sickly) yellow on most films. This is because tungsten light has a lower "color temperature" than daylight.

Strictly, "color temperature" refers to the temperature to which a black body must be heated to emit light of a particular color, but in practice, it can be used to describe the color of most kinds of light (though not fluorescents). It is measured in Kelvins; these are the same size as degrees Celsius but start at absolute zero, about -373°C, so 1750K is about the same as 1377°C. Slightly confusingly, a lower color temperature equates to what we see as a "warmer" light (more reddish-yellow).

There are three ways to make sure that the film and the light source match. One is to use film matched to the light source ("Daylight" or "Tungsten"). The second is to use filtration on the camera lens. And the third is to filter the lights themselves.

"WHITE LIGHT" AND FILM BALANCE

Although the eye can accept many lights as "white," color temperatures can vary widely and will record very differently on film. A candle is about 1750K; domestic lamps are about 2500-2800K (the higher the wattage, the higher the color temperature); professional tungsten lamps are 3200K; photofloods are 3400K; and "standard" daylight is defined as anything from 4800K (English daylight, international white light SB) through 6500K (American daylight, international white light SC) to 7500K (American overcast daylight, international white light SD). Light from a blue north sky can be as high as 20,000K.

"Daylight" films are typically balanced for anything from 5500K to 6000K; "Type B" tungsten films (the usual variety) are balanced for 3200K; and "Type A" tungsten films (now effectively obsolete) are balanced for 3400K.

Light with gel (BELOW)

Most good-quality tungsten lights have accessory holders that allow them to be fitted with gel filters for light correction. Modern filters are acetate, not gelatine (gel), but the old name still holds. "Gelling" the lights instead of using filtration on the cameras allows you to mix tungsten and flash, and minimizes the distracting blue cast in the viewfinder.

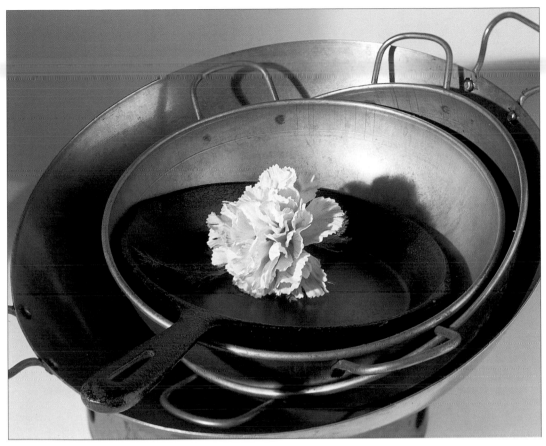

No filtration

Daylight and tungsten (ABOVE and RIGHT)
Both pictures were shot on the same daylight-balanced film, Fuji Astia, using the same light, a tungsten focusing spot. Without any filtration (above), the result is warm and golden; with a Lee "full-blue CT" filter over the light (right – "CT" stands for "color temperature"), the effect is much closer to "natural" color. You may, of course, choose to use the "wrong" sort of light (or film) for a particular effect.

With a "full-blue CT" filter

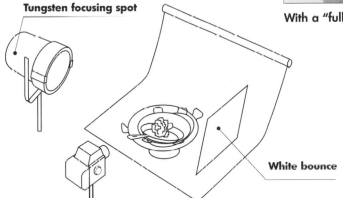

Tungsten focusing spot

White bounce

TECHNIQUES AND EQUIPMENT

Mixed Lighting

WE HAVE ALREADY seen that daylight and tungsten light record differently on film. Fluorescent lighting can be even more of a problem; some fluorescent lights record like daylight, but others are very green. Worse still, fluorescent lighting can never be corrected fully, because unlike daylight or tungsten, it does not have a continuous spectrum and cannot therefore be assigned a meaningful color temperature. On a bad day, you may find yourself trying to shoot by mixed daylight, tungsten, and fluorescent lighting.

There are at least five solutions. The easiest is to shoot black and white, where color differences do not matter. Another easy approach, in color, is just to live with it; fast films often reduce the differences between different kinds of lights. Sometimes, too, you can turn the artificial lights off, and shoot only by daylight. Another possibility is to replace (or overwhelm) the existing lighting with controllable photographic lighting, though it can be hard to retain the ambience of a place if you do this. Still photographers specializing in interiors, and movie crews, often "gel off" lights so that they all match the film. Amber gels over the windows make daylight match tungsten, blue gels over tungsten match their light to daylight, while magenta gels over greenish fluorescents can often give an acceptable match to daylight.

Continuous light plus flash (BELOW and OPPOSITE)
With only tungsten light, the arm of the metronome is distractingly blurred (below left); with only flash, it is frozen, and it looks as if it is stopped (below right). By combining the two (opposite), there is a much greater sense of movement. Arguably, this technique of "freeze plus blur" is as much an invented convention as perspective. Because movement was involved, it was not enough just to juggle shutter speed and aperture: the distance of the lights also had to be altered so as to give the right intensities across quite a narrow range of speeds (1 second to $1/4$ second). You can also see the slightly different colors of the light, even though the tungsten light was gelled to approximate daylight balance.

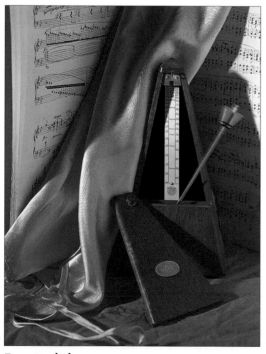

Tungsten light

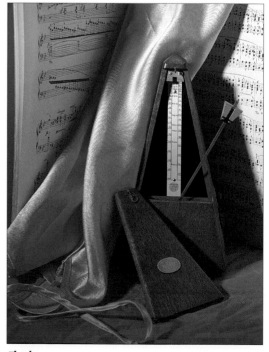

Flash

TECHNIQUES AND EQUIPMENT

TECHNIQUES AND EQUIPMENT

Tungsten plus flash

MIXED LIGHTING AND EXPOSURE

Combining continuous light and flash can cause metering problems. Opening up the lens increases exposure to both the continuous source and the flash. As the flash duration is fixed, changing the shutter speed will only affect the exposure to continuous light sources – shutter speed is irrelevant. When combining sources, it is generally easiest to meter for the flash first and establish your aperture, and then to vary the shutter speed to control the influence of the tungsten light.

TECHNIQUES AND EQUIPMENT

Three Basic Rules

ONCE YOU ARE aware of quality of light, it is much easier to light your pictures convincingly. There are, however, three common mistakes that are so fundamental that they need to be countered by three basic rules.

● **There should only be one set of shadows, and they should all point in the same direction.** This is the most basic rule of all, and the most dangerous to break: you need to be a genius, or to have a very unusual subject, to get away with it. Sometimes – when you are lighting an interior, for instance – you have no choice; in that case, try to keep the conflicting shadows as soft and unobtrusive as possible.

● **Wherever possible, the background should be far enough from the subject that it can be lit separately.** This is one of the secrets of professional portrait photography in particular. A common problem with amateur portraits is awkward shadows on the background, generally because there is not enough room to separate the subject and the background adequately. Although the advice for portraiture is always to use longer focal lengths whenever possible, it is sometimes better to use a shorter focal length and to allow more space between the subject and the background. The picture of the ballerinas opposite, for instance, was taken with a 150mm lens on a 4x5inch camera, roughly equivalent to a 45mm lens on a 35mm camera. Even in a fairly big room, there was no room to use anything longer.

● **Whenever a shadow is unavoidable, it should be treated as part of the composition.** Composition is principally a matter of masses of light and shade (and of color, if you are shooting on color film) and you cannot just ignore a large, dark area in a picture. Sometimes, indeed, the shadow can be a principal part of the composition.

Use the shadow as part of the composition (LEFT)
Keeping an eye on shadows can sometimes lead to offbeat, but intriguing, pictures. This is a red filter, held between finger and thumb under bright sun. The shadow of the hand is the principal part of the composition; the filter has tinted the light red.

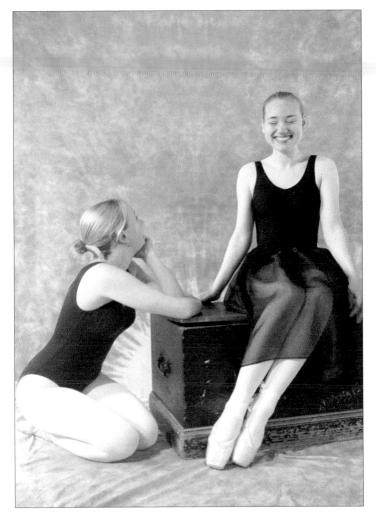

Keep the background distant (LEFT)

The cloth backdrop is about 5 feet (1.6 meters) behind the chest that the girls are sitting on. The available light is supplemented by a 500W Photo-pearl to camera left (the girls' right), carefully positioned to cast no shadows on the background.

Avoid conflicting shadows (BELOW)

You can see light coming from at least three directions – the window to the right, the window at the far end of the bar, and the interior lighting – but the area is big enough, and the shadows are soft enough, that it does not really matter.

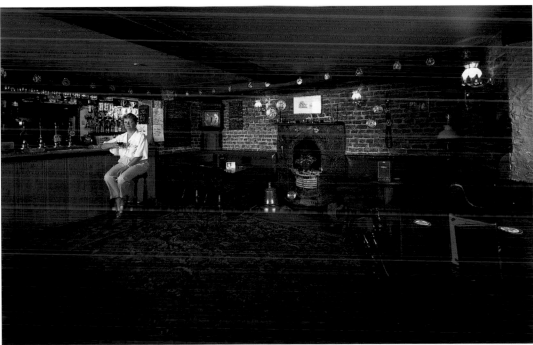

TECHNIQUES AND EQUIPMENT

TECHNIQUES AND EQUIPMENT

Key, Fill, and Effects

REGARDLESS OF THE light sources you use – daylight, flash, reflectors, mirrors, or anything else – all lights can be grouped into three kinds: key, fill, and effects.

The key is the main light. It determines the shadows and the principal highlights. If you are working with a single light, then by definition, this is the key light.

The fill is the secondary light, which (as its name suggests) "fills" the shadows, making them less intense. Normally, the fill is a broader, softer light than the key; if it is too hard and directional, you run the risk of conflicting shadows. Often, you can get perfectly adequate fill with a reflector instead of using an additional light. This reflects the "spill" from the main light back onto the subject.

Effects lights are used to emphasize particular points in a subject: creating highlights, backlighting hair, or adding sparkle. Normally they are small, highly directional lights. Again, instead of using several lights you can often use mirrors to reflect part of the light from the key onto appropriate parts of the subject.

LIGHTING RATIOS

The ratio between the key and the fill is known as the lighting ratio. In black and white, lighting ratios as high as 32:1 can be used, but in color, if the highlights are more than about eight times as bright as the shadows, you have a choice of burned-out highlights or blocked-up shadows. As lighting ratios approach 1:1, the light becomes steadily flatter, but even at 1:1 a hard, directional light can still function as a key: it determines the highlights, if not the shadows.

Portrait (BELOW and RIGHT)
The main picture (opposite) uses three flash heads: a key to camera left, a fill to camera right, and a hair light behind the model. With the key alone, the background is unlit and the model's face is in dramatic profile (below left); a tiny amount of spill, reflected back from camera right, barely delineates the unlit side. With the fill alone, the shape of her face is emphasized but the hair is considerably less dramatic (below center); the background is lit by spill from this light. Effects lights do not affect the exposure but add sparkle or concentrate attention on a particular part of the image, in this case the hair (below right).
Exposure: f/16 on ISO 50 film (Ilford Pan F).

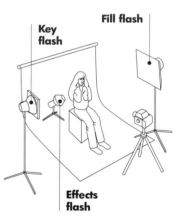

Key flash · Fill flash · Effects flash

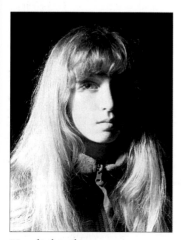

Key light alone

Fill light alone

Effects light alone

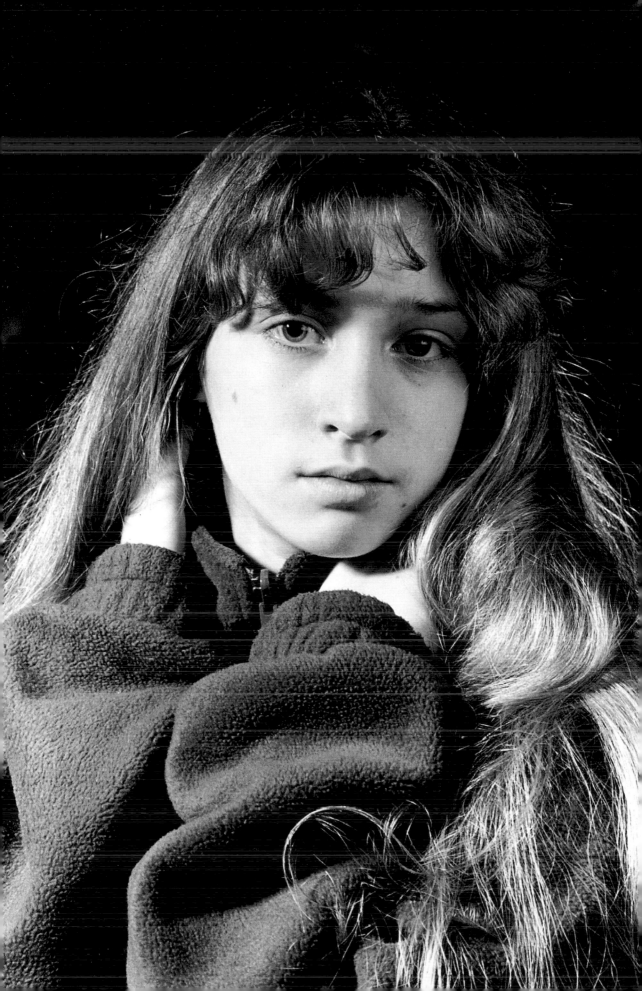

Lighting, Film, and Reciprocity

As MENTIONED ON page 16, film can be used to control contrast. Slow films are normally contrastier than fast ones, and (with black-and-white films) prolonging development increases contrast. If you are in full control, you can make the lighting more or less contrasty in order to make it suit the film in use, so the main consideration is which film delivers the tonality you like best – and in color, which gives you the most pleasing color rendition. In 35mm, grain is also a consideration. With any format, though, you need to consider "reciprocity failure."

Exposure is made up of two components: intensity and time. Normally, you can compensate for reduced intensity by increasing time; halve the intensity, and you have to double the time. This is called the "reciprocity law." Outside the range of exposure times for which the film is designed, though, you have to give extra exposure ("reciprocity law failure") and with color films you may also have to adjust filtration because of color shifts.

The manufacturers' specification sheets for color slide and monochrome films will tell you how much extra exposure to give for very long or very short exposures (typically, over one second or under $^1/_{1000}$ second) and whether you need filtration. Long-exposure (type "L") color negative materials are typically designed to be exposed between

$^1/_{10}$ second and 100 seconds. Many of the color pictures in this book were shot on Fuji Astia film, which requires no exposure compensation or additional filtration, even for one-minute exposures.

Films on location (BELOW)

When you cannot control the light, as is often the case on location, remember that a lower-contrast film will hold subtle detail in both highlights (look at the nets) and shadows (the stern of the boat). With a contrastier film you might have to choose between losing either highlights or shadows. Exposure: $^1/_{250}$ second at f/8 on ISO 100 film (Fuji Astia).

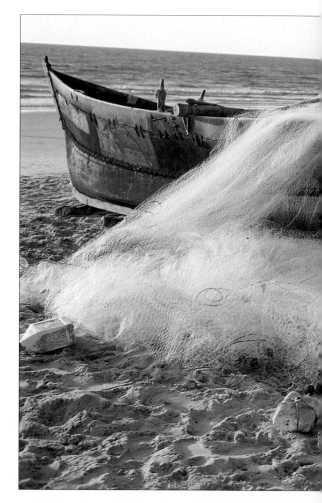

FILM CHOICE

Film choice is a very personal matter, and it is important not to be influenced by fashion or other photographers. Contrast, color saturation, grain, and "color signature" (the balance of tones and colors) can all vary, and the only way to see what suits you is to try as many films as possible. Once you find a film you like, though, stick with it. Only by working repeatedly with one film can you find out how it responds to different conditions, and how it renders different tones and colors.

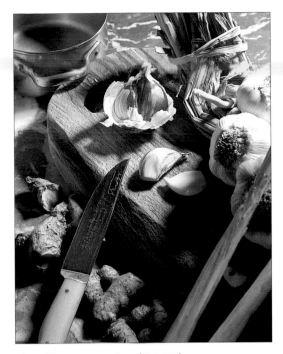

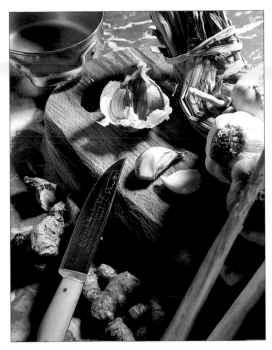

Slow film – Fuji Velvia (ISO 50)

Normal film – Fuji Astia (ISO 100)

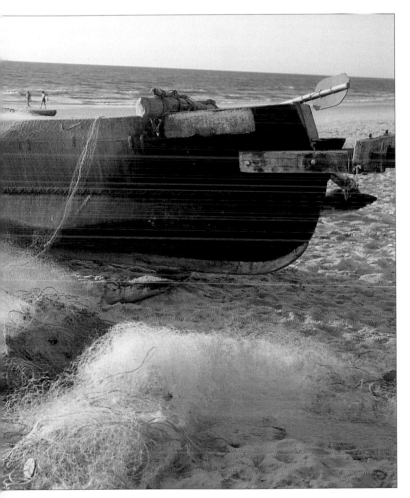

Films for studio use (ABOVE)
Although identically lit, one still
life was shot on Fuji Velvia
(ISO 50), the other on Fuji Astia
(ISO 100). There are subtle but
clear differences: Velvia
(above left) gives more contrast
on the knife blade and brighter
colors in the garlic; Astia
(above right) is subtler and is
less assertive. Exposure was
f/16 in both cases; the power
of the flash was adjusted to
compensate for the slower
speed of the Velvia.

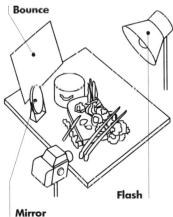

Bounce

Flash

Mirror

TECHNIQUES AND EQUIPMENT

TECHNIQUES AND EQUIPMENT

High Contrast

HIGH-CONTRAST IMAGES can be of two kinds. One is like a conventional black-and-white print, but with a very short grey scale so that small differences of tone are emphasized. This can be obtained by overdeveloping to get a contrasty negative (try developing a slow film for twice the manufacturer's recommended time) and then printing onto very contrasty paper. The other approach "drops out" all grey tones so that the image is reduced to pure black and pure white. This was traditionally done using lith film, as described in the box at left, but today it is more often done with a computer program such as Adobe Photoshop.

The lighting principles remain the same for both approaches. You need flat lighting and clearly recognizable shapes, or your image will become unreadable as areas of shadow block up into solid black. On-camera flash (or better still ring flash, page 48) is ideal for many subjects, while for close-ups and still lifes you generally need a large soft box (page 64) to give the flattest possible lighting; you may even wish to consider shadowless lighting (page 100). To get a "preview" of your final effect, either look through a Pan Vision filter (a deep olive green) or simply stop well down and look through the viewfinder. Either technique reduces the picture to areas of light and dark, without detail.

USING LITH FILM

The traditional way to make high-contrast images is by enlarging a conventional negative onto ultra-high-contrast lith or line film to make a contrasty interpositive, then contact-printing this onto another sheet of the same film to make an internegative in which all grays have disappeared and the image is pure black and pure white. Special lith developer is normally used to develop both films. Finally, the internegative is contact printed onto paper. By varying the exposure of the original interpositive, the proportions of light and dark on the final print can be controlled.

High-contrast effects (BELOW)
The handle of this corkscrew is made from a vine root. Very soft lighting was essential to keep the shadows to a minimum; lighting was a large soft box about 20 in (50 cm) above the subject, that was resting on a sheet of white paper. Take particular care with such subjects to align them so that they "read" well; if necessary, use black bounces (page 56) to help differentiate shiny areas, such as the screw itself.

Lith effects (RIGHT)
The shape of an ancient press camera remains instantly recognizable to this day, the more so if it has a flashgun attached. The sequence of pictures shows the way in which mid-tones can be made to read as either white or black by varying exposure (if you are using lith film) or adjusting brightness (in a computer program). The larger picture uses additional computer manipulation (the "curves" control in Adobe Photoshop) to reverse the dark mid-tones to allow the retention of detail in all but the darkest shadow areas. All four shots are from the same negative; the subject was lit with a large reflector above the photographer's left shoulder.

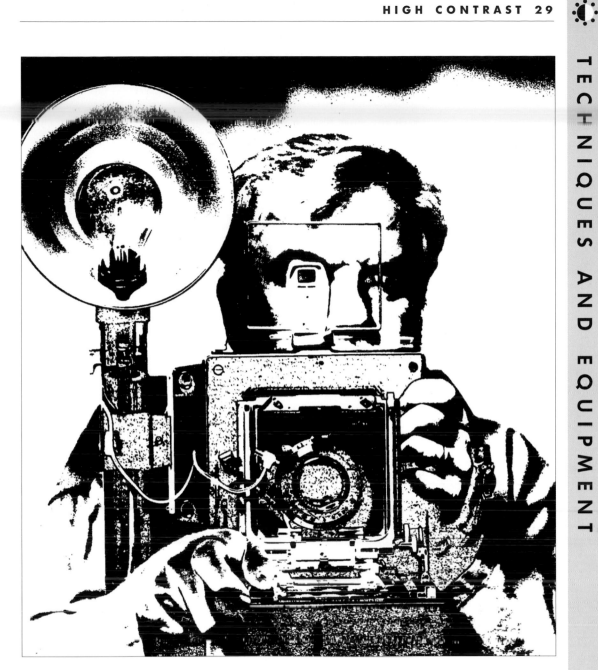

Computer-manipulated image

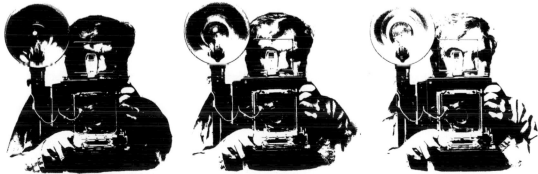

Dark lith image　　　　　**Medium lith image**　　　　　**Light lith image**

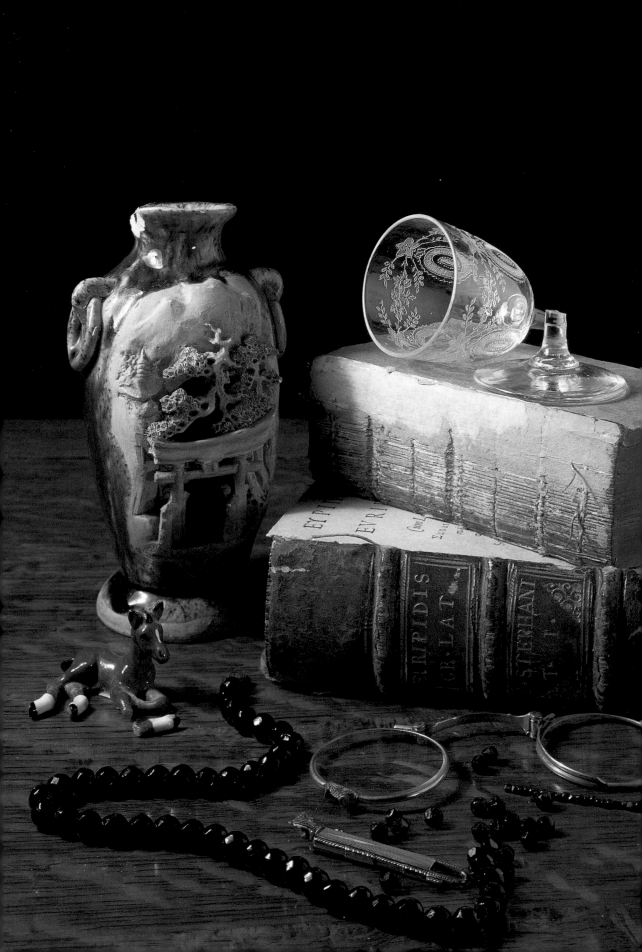

Lights and Lighting

TECHNIQUES AND EQUIPMENT

Available Light

A SECTION ON USING available light may seem like a cop-out in a book on lighting, but intelligently used available light can look every bit as good as controlled light – sometimes better – and it has the great advantage that it is free.

Portraits by window light have a long and honorable history, and indeed the earliest photographers used nothing else. The orientation of the window is, however, important. A north-facing window (south-facing in the southern hemisphere) will never receive direct sunlight, so the light is very even in quality. Prized by both painters and early photographers, this evenness remains useful today for monochrome, but the light is somewhat blue and a warming (81-series) filter is usually necessary for color.

If sun streams through the window, you can shoot some extremely effective still lifes, but you have to work quickly because the shadows move surprisingly fast; it is much easier to use controlled light. Direct sun through a window is often too harsh for portraiture, though, so some diffusion is desirable. You may be able to use curtains. Alternatively, an old professional trick is to tape tracing paper or drafting film (as used for drawing plans) across the window; this also gives privacy, which is useful for nude photography.

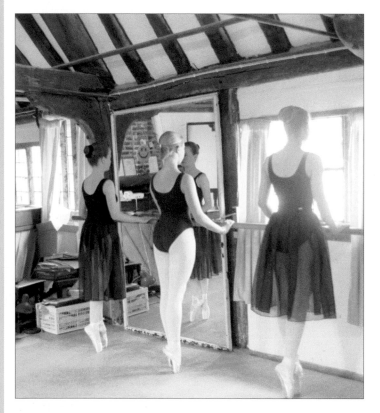

BACKGROUNDS

A major problem with available-light portraits can be the background. Things that pass unnoticed in everyday life can suddenly become very obtrusive in a photograph – things like telephone jacks, TV aerial wires, window fasteners... the list is endless. Before you sit your subject down, or set out your still life, look very hard at the background and weed out as much irrelevant material as you can.

Ballerinas (ABOVE)

These 16th-century windows face north, so they never receive direct sunlight – the sun was actually streaming in through the windows on the other side of the room, behind the girls, providing an excellent fill-in.

Even so, the contrast was high, so a very fast negative film was chosen to "tame" the brightness range. Exposure: $1/60$ second at f/4 on ISO 1600 film (Fujicolor), with a 35mm Summilux on a Leica M2.

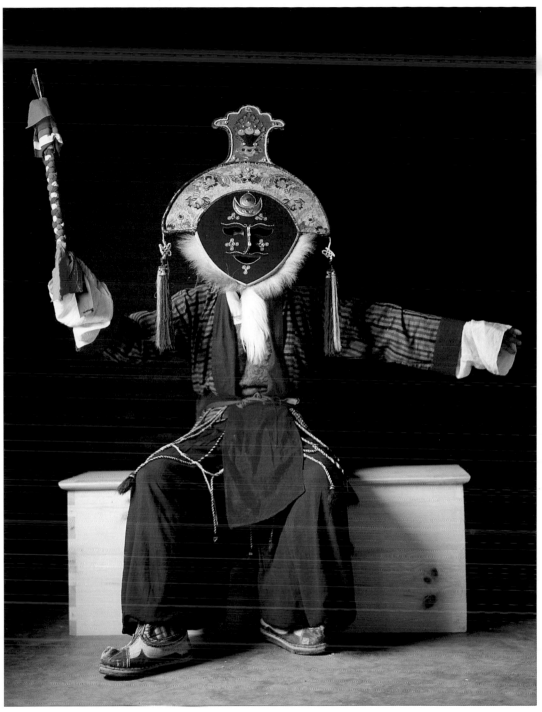

The Hunter (ABOVE)

The Hunter purifies the stage in traditional Tibetan Lhamo drama. This was shot by the light of an open door to the subject's right (camera left), which created a perfect "soft box." A Lastolite collapsible reflector to the subject's left (camera right) provided adequate fill. The rain was pouring down outside; the actor is sitting on a prop chest, in the auditorium of the Tibetan Institute for Performing Arts in Dharamsala. Exposure: 1/2 second at f/8 on ISO 64 film (Kodak EPR) .

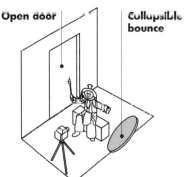

Open door

Collapsible bounce

Domestic Lamps

DOMESTIC AND OTHER room lights have the same advantages as sunlight – they are already there, and you do not need to buy anything else – but they also have three significant disadvantages.

The first drawback is that as light sources, they are pretty weak, so you generally need to use long exposures, or wide apertures, or fast films; sometimes you need all three.

The second drawback is that they vary widely in color temperature, and therefore cannot be corrected with simple, single filters. The usual conversion filters for photographic lamps (80A on the camera lens, or full-blue CT on the lamp itself) are not strong enough, so you need to add further filtration, which reduces the light available. For a 100W lamp you generally need 80A plus 80C on the camera lens,

Kathkali dancers applying make-up (RIGHT)
The lighting is absolutely obvious here: a single, bare bulb, on a long cord. Often, the most successful way to use domestic or similar lighting is to incorporate it into the picture. That way, people can see why the picture is lit as it is. The film was 3M 640T, a fast, tungsten-balance slide film; a better choice today might be an ISO 1600 negative film, preferably used with filtration at the taking stage. Exposure: 1/30 second at f/1.4 on ISO 640 film (3M 640T).

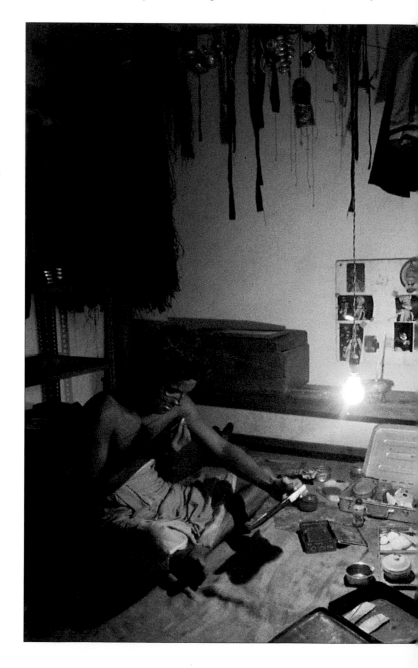

or a full-blue CT plus quarter-blue CT on the lamp. Even then, lamp shades may add their own colors to the light, and filtering all the light sources can be difficult.

The third and perhaps greatest drawback is that overhead lights are often awkwardly positioned for photographic purposes, rather like the overhead sun at midday, and that even movable lamps, such as table lamps and standard lamps, cannot always be positioned where you want them; you may have to move the furniture around considerably to get the light where you want it.

OVERRUN LAMPS – A WARNING

A piece of advice that appears in some older books is to replace domestic lamps with 275W or 500W photographic lamps, such as photofloods or Photo-pearl (page 40). These will give you much more light, and will bring the color temperature up usefully. On the other hand, the risk of fire can be considerable, especially with photofloods, and burnt fingers are a virtual certainty. We are not given to warning against unimportant risks, but this is something that we would find it hard to imagine ever doing.

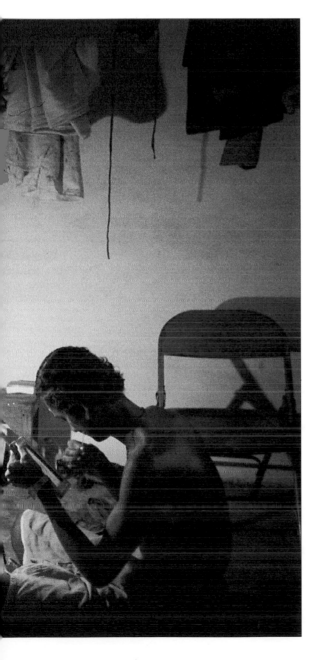

Mandy (ABOVE)

Table lamps and standard lamps are quite difficult to position exactly where you want them, and although the light is directional, it is not uniform. As a result, you quite often have to adapt your subject's pose to make it suit the light. Mandy looked toward the light, to reduce an awkward nose shadow and provide modeling on the cheek. Pictures were removed from the wall behind her, to avoid distracting shapes in the background. Depth of field is shallow, even with a fast film, and a tripod was necessary. Exposure: $1/15$ second at f/4 on ISO 400 film (Ilford XP2).

TECHNIQUES AND EQUIPMENT

Desk Lamps

THE DIFFUSE LIGHT of traditional domestic lamps is easy on the eyes and can be flattering. For many photographic purposes, however, you need light that is both more directional and more plentiful. Fortunately, desk lamps give you exactly this, and they can be bought cheaply new, or even more cheaply secondhand.

Desk lamps normally have to be used close to the subject, to keep exposures short, and heat can be a problem. They are ideal for strongly directional sidelighting, though they can be used beside the camera for frontal lighting, behind the subject for backlighting, or even for direct overhead lighting. Be careful, though, that parts of the lamp itself do not get into shot.

Most desk lamps take standard household bulbs, but they have reflectors rather than lampshades, and the light is more directional, so filtration is easier. Small "point source" tungsten halogen bulbs are highly directional and normally require less correction (typically 80B) but are harder to find, cost more to replace, and are less versatile than regular bulbs. The lamps themselves tend to cost more, too.

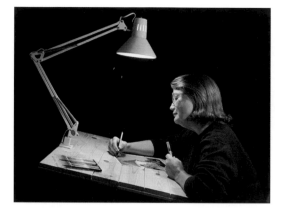

Frances (ABOVE)
Here, a desk lamp provides the key light and is also an important part of the composition. A second desk lamp is placed out of shot, above Frances's head and to camera right, as a hair light. An overhead room light provides the fill. Exposure: $1/8$ second at f/8 on ISO 400 film (Ilford HP5).

Desk lamps (RIGHT)
From left: 1950s "infra-red" lamp with bulb replacing heating element; cheap goose-neck light; original Anglepoise; 1970s magnifier with circular fluorescent tube; cheap 1970s desk lamp; 1950s desk lamp; modern "infra-red" lamp with bulb replacing heating element; cheap modern Anglepoise copy.

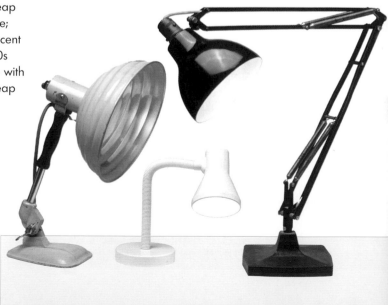

Broken treasures (RIGHT)
For still lifes, the advantage of a
desk lamp is that it can be
positioned anywhere – high,
low, or even directly above the
subject – to give a clearly
directional light. The lamp used
here was placed low and to
camera left, with a 200W bulb.
A "full-blue" 80A gel filter was
placed in front of the lamp.
Exposure: 10 seconds at f/11
on ISO 100 film (Fuji Astia).

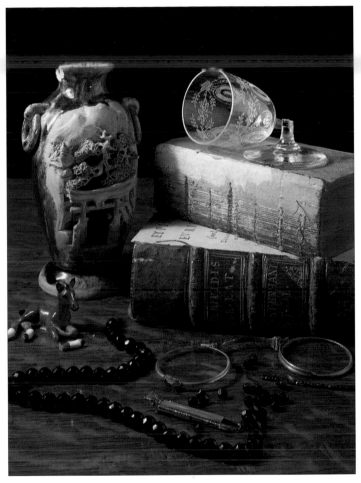

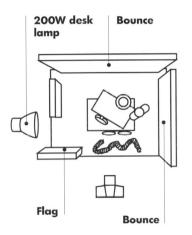

200W desk lamp **Bounce**

Flag

Bounce

TECHNIQUES AND EQUIPMENT

TECHNIQUES AND EQUIPMENT

Other Light Sources

YOU DO NOT necessarily have to buy new lights in order to extend your repertoire beyond available light, domestic lamps, and desk lights. A surprisingly versatile light source, which was used for quite a number of pictures in this book, is the slide projector. Slide shows are no longer as popular as they used to be, and secondhand projectors are often available at bargain prices if you do not have one already. Not only do they give a strong and highly directional light, they can also be used to project images or patterns onto the subject. Older projectors with 1000W bulbs can "fry" anything you put in

the gate, and more modern fan-cooled projectors can deliver very nearly as much light, a lot more manageably, with as little as 300W.

Another possibility is a small, powerful flashlight (torch) which can be used hand-held in a darkened room to "paint" a subject with light from different directions, rather like a lower-powered version of a light brush. It takes some practice before you can get even lighting and consistent exposures; keep the light moving to avoid "hot spots."

In both cases – projectors and torches – you can correct the light to match daylight by taping old gel filters over the lens.

Flashlight (torch) as a light source
(BELOW and RIGHT)
This Tibetan statue was lit with a small Mag-Lite flashlight (torch), color-corrected with a piece of cut-down 80A gel filter. Color negative film was chosen to allow correction of over-exposure and slight color shifts in printing. You will need to "waste" several frames in order to learn this technique: two different exposures from the same film are shown here.
The differences are explained solely by the different lengths of time that the individual areas were illuminated.
Exposure:
30 seconds at f/8 on ISO 100 film (Fuji Reala).

Unevenly lit attempt

Evenly exposed version

UNUSUAL LIGHT SOURCES

In the days when smoking was more widespread, a relatively common tour de force was a portrait of someone lighting a pipe or cigarette, illuminated only by the match they were using. With modern fast films, such shots are much easier. You normally need (at least) one match to meter the shot, and another for the picture. Firelight can make an

attractive picture of someone on a hearthrug – try to make the flames a small part of the shot, or omit them altogether, because they burn out to a featureless highlight – and the light of a TV screen or computer monitor can be used for telling portraits. Metering is exactly the same as for any other shot, and remember to turn off your flash!

TECHNIQUES AND EQUIPMENT

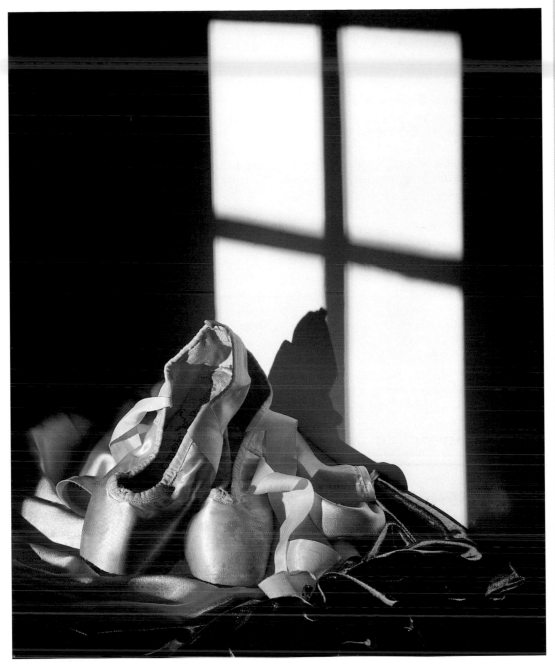

Slide projector as a light source (ABOVE)

Even if you already have a good slide projector, you may want to look for a cheap secondhand model for lighting, so you don't have to worry if it gets banged around a bit. This picture was made with a 300W Gnome, long out of production, as the sole light. The "window" was made from a couple of matchsticks jammed into a slide mount; an old Wratten 80A gel filter taped across the lens provides adequate color correction. Exposure: 1 second at f/16 on ISO 100 film (Fuji Provia RDP2).

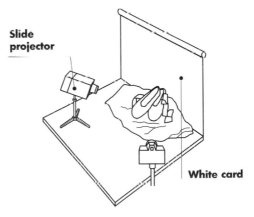

Slide projector

White card

Low-cost Hot Lights

HOT (TUNGSTEN) LIGHTS are so-called to distinguish them from cool-running flash. Depending on the reflector design, they can give anything from a harsh, glaring light to a soft, broad source; and, of course, they can be diffused, though you need to use fireproof diffusers (normally fiberglass) or to keep the diffuser a good distance from the bulb (at least 12 in/30 cm).

Argaphot (or Nitraphot or Photo-pearl or "hundred-hour") bulbs run at 3200K, are normally of 500W output, last for about 100 hours (as the name suggests), and are about twice as efficient as standard domestic bulbs, so a 500W gives as much light as 1000W of domestic lighting.

Photofloods are still brighter (a 275W photoflood is equivalent to 800W of conventional domestic lighting, while the 500W delivers the equivalent of 1600W) but they also run dangerously hot, have a color temperature of 3400K instead of 3200K, and are short-lived: they are designed to run for just a few minutes at a time, with a total life at full power of two hours or less. Today, the cost differential between photofloods and Argaphots is modest, and Argaphots are a much better buy.

Two unexpected options are home security lights and builders' lights, designed to provide illumination on building sites. Both are available cheaply from builders' suppliers, and typically use long-lasting 300W or 500W tungsten-halogen lamps. The light is broad but harsh, and no choice of reflectors is available, but the light can be bounced or diffused to soften it.

Despite their power, low-cost hot lights have to be used fairly close to the subject if you want short exposure times; this limits their usefulness for subjects that are sensitive to heat – including people.

Hot lights (RIGHT)

Builders' lamps (near left) make good, cheap floodlights. Photoflood holders (center) are usually crude and simple, partly because they have to withstand immense heat and partly because they are built down to a price: the only reason to use photofloods is because you cannot afford anything better. Modern lights like the Paterson "Interfit" (right) are designed to be used with 500W "hundred-hour" Argaphot bulbs. Although these deliver less light than photofloods, they run cooler, last longer, are less likely to "blow" when they are moved, and represent a good low-cost compromise between raw power and convenience.

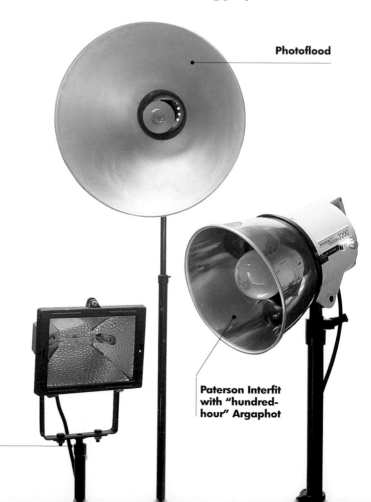

Photoflood

Paterson Interfit with "hundred-hour" Argaphot

Builders' lamp

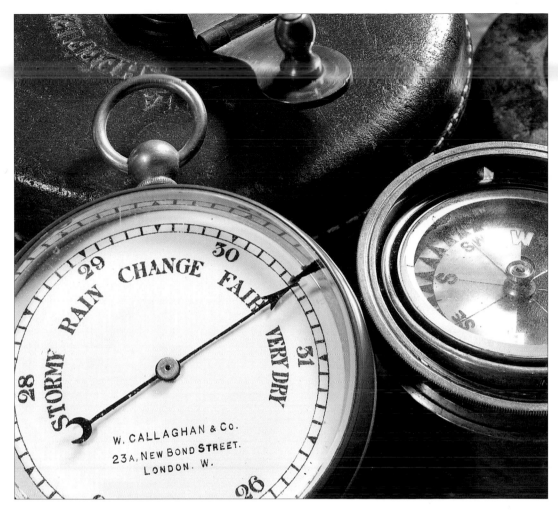

Barometer and compass (ABOVE)

Backlighting from the right reveals good detail on the faces of the instruments and creates interesting patterns of light and shadow; a bounce to camera left adds roundness to the shapes, as well as providing a fill. The actual lamp is a single Interfit unit with a 12-in (30-cm) reflector. Exposure: 5 seconds at f/11 on ISO 64 tungsten-balance film (Fuji RTP).

Bounce

Tungsten lamp
with 12-in
(30-cm) reflector

DIMMERS

Most bulbs eventually "blow" as a result of thermal shock when they are switched on. Using a dimmer allows you to raise the voltage gently, greatly reducing this shock and increasing the life of the lamp considerably; this is especially useful with photofloods. The only problem lies in finding dimmers that can handle powerful lights: a 200W domestic dimmer is not powerful enough for a single 500W bulb, let alone two. Specialist electrical retailers may be able to help.

TECHNIQUES AND EQUIPMENT

Professional Tungsten Lighting

THERE ARE TWO distinct generations of professional tungsten lighting. The old generation (still in production) is like movie lighting and (with the exception of the smaller units) is normally hired rather than bought. Most traditional lights are big, heavy, and expensive and use very expensive but long-lived specialist bulbs. Focusing spots are available in a wide range of powers, from 150W or 250W (an "inky dinky") through 500W or "half k" (for kiloWatt – also known as a "pup") to 1000W ("one k") and 2000W ("two k"). Even bigger lamps are available, and are widely used in the movies, though rarely by stills photographers. As well as spots, there are also non-directional floods and "troughs" (two or more bulbs in large, shallow reflectors).

The new generation is mostly in the 600W to 1000W range, with 800W being one of the most usual sizes; the tungsten-halogen bulbs are much more easily affordable. The lamps themselves are mostly small, focusing spots, and are often known generically as "Redheads" after one of the most popular trade names (from Ianero).

Paradoxically, low-cost tungsten lights (as described on page 40) may be more versatile for the amateur than professional tungsten lighting. Professional lights are normally single-function (spot, flood, or "trough") while amateur outfits offer a range of reflectors and light modifiers, though a small, professional focusing spot is a useful supplement to a low-cost tungsten outfit.

Pro tungsten lamps (BELOW)
Old professional lamps, such as this 250W Cremer focusing spot, can sometimes be found cheaply, and allow excellent control; but tungsten halogen lamps, such as these two 800W Beard focusing spots, are brighter, lighter, and take cheaper bulbs. In both types, a focusing knob moves the bulb back and forth in the reflector.

800W focusing spot

250W focusing spot

800W focusing spot

POWER REQUIREMENTS

A photographic lamp delivers more heat than an electric heater of the same wattage, so anything over 2.5kW will be uncomfortably warm. As watts = volts x amps, a British 230V ring main allows you to draw 2990W through a 13A plug (13x230), but a typical American 15A, 115V socket allows you to draw only 1725W, so three 500W bulbs is the maximum practical loading. If you need more power, use two separate sockets. Overloading a socket will at best blow fuses and at worst can cause fires.

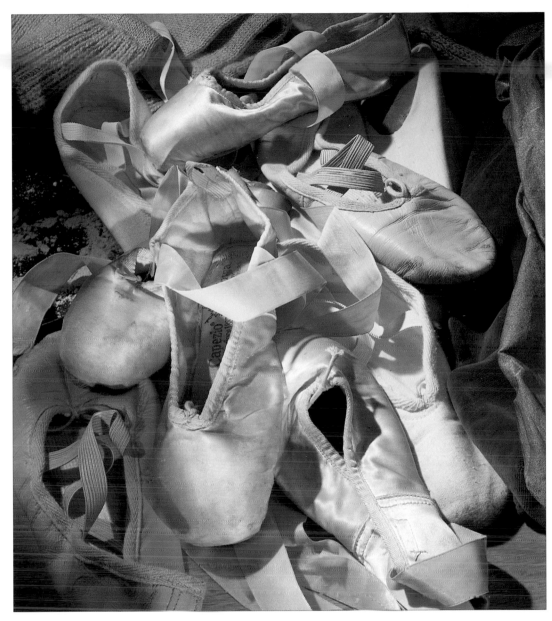

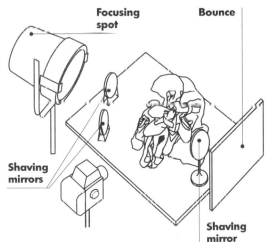

Focusing spot

Bounce

Shaving mirrors

Shaving mirror

Ballet shoes (ABOVE)

A single Beard focusing spot, to camera left and slightly behind the subject, was used to light this jumble of dance and ballet shoes, leg warmers, and a rosin tray. A sheet of white polystyrene to camera right bounced light into the unlit side (see page 50); and three mirrors (see page 54) reflected light from the main light onto areas that needed emphasis. A powerful lamp like this allows the use of a small aperture and a reasonable shutter speed. Exposure: 1/4 second at f/11 on ISO 100 film. The light was "gelled" to daylight balance.

TECHNIQUES AND EQUIPMENT

TECHNIQUES AND EQUIPMENT

Low-cost Flash

ON-CAMERA FLASH is highly convenient, and provided you respect its limitations, it can be used to create simple but dramatic shots. Alternatively, make a feature of its characteristic harsh light and offset shadows in "newsy" shots. Best of all, use it as a form of supplementary lighting: see the portrait on page 128 for an example.

Most built-in flashes are pretty feeble, but bigger add-on units are more versatile and do not cost a fortune. Tilt or swivel the head to bounce the light off nearby light-colored surfaces, or use commercially available diffusers, for a softer, more forgiving light.

Although there are occasional articles in the photographic magazines about how to take "professional quality" pictures with small flash units, they are cruelly misleading and the pictures are often faked, using more expensive flash units with modeling lights – though one possible way around this is described in the picture caption opposite. Even so, professionals often use small, mains-powered, self-slave units to supplement their main lights, especially for lighting interiors; and for copying or other fixed-light set-ups, you do not need modeling lights anyway.

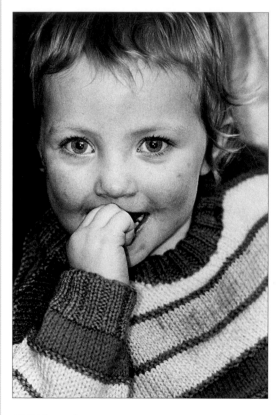

Child (ABOVE)
When using the flash built into your camera, come in close to avoid awkward shadows on the background; choose a wide aperture to concentrate interest on the eyes – still further reducing the importance of the background – and shoot on black-and-white film to avoid red-eye.

SLAVES

A "slave" flash is one that fires as soon as it receives the light from another flash, thereby removing the need for connecting wires. The response time is so fast that it is virtually instantaneous.

There are many small, modestly priced self-slaving units on the market. They screw into domestic light sockets. These (above), from Paterson, have the advantage that the internal reflector can be reversed to give a 130° "bare-bulb" effect or a 45° reflector; both options are shown here, together with a choice of diffusers and coloring heads – all are interchangeable. You can also buy add-on slaves, which connect to any flash gun and convert it to slave operation.

Star-struck (BELOW)

With a still life, you can focus and compose using a household bulb in a cheap reflector, then unscrew it and replace it with a small slave flash for shooting the actual picture. This technique does have its drawbacks: light distribution is not identical, light output is modest, and you need oven gloves to change the lamps. The reflector was 12 in (30 cm) in diameter, and even though it was less than 30 in (75 cm) from the subject, the working aperture with the flash was still only f/11. Exposure: f/11 on ISO 100 film (Fuji Astia).

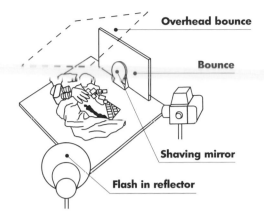

Overhead bounce

Bounce

Shaving mirror

Flash in reflector

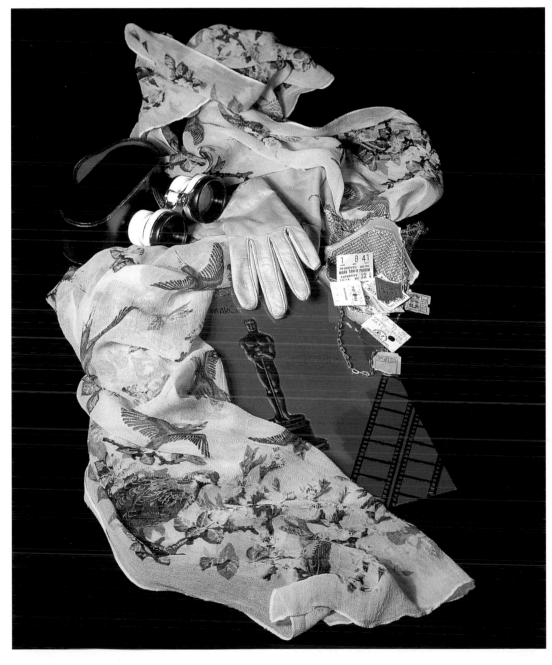

Studio Flash

UNDOUBTEDLY THE MOST popular form of lighting today, and arguably the most versatile, is the monobloc electronic flash. The power supply is incorporated in the flash head and can (in the more powerful versions) be switched to lower powers. Some switch in discrete steps (typically 1/2, 1/4, and 1/8, often 1/16, and sometimes 1/32) while others are can be varied steplessly. Usually, though not always, the modeling light can also be switched proportionally to the flash power.

Some studio units use a separate generator and head(s), but these are becoming less and less common except for very high-powered units (2000 to 5000 Watt-seconds). "Asymmetric" units can feed different power levels to different heads; other units split all the charge equally.

The only thing that normal studio flash cannot do at least as well as continuous lighting is provide a near-point source with almost parallel light beams; there are a few projection flash units that can do this, but they are rare and expensive. With snoots and honeycombs (see page 62) these limitations can to some extent be "faked out" to make the lights even more versatile.

FLASH POWER

Studio flash power should be rated in Joules or Watt-seconds (J or W-s), but different manufacturers' units with the same power rating do not all deliver the same amount of light. This is partly because of variations in efficiency, and partly because of the unsavoury habit of using "equivalent Joules": a manufacturer may call his 900 W-s unit a "1200" or even an "1800" because he believes it is the equivalent of another manufacturer's unit of that actual power. True W-s ratings of monobloc units range from about 125 to about 1200, and can usually be discovered if you read the manufacturers' specifications closely. They are a useful guide, but the only real way to compare two flash units is to test them side by side.

Monobloc heads (BELOW)
Some manufacturers supply two lines of flash, a more powerful "pro" line and a budget version with reduced features and less power. The smaller unit (left) is a Courtenay Interfit 150: 150 W-s, and a choice of full or half power. The bigger unit is a Courtenay Solapro 1200: 1200 W-s, continuously variable output across four stops, and on-board diagnostics for rapid fault-tracing. Always buy the most powerful light you can afford – you can turn down the power of a big unit, but you cannot turn up the power of a small one.

Low-power monoblocs (RIGHT)
Even low-powered units can be surprisingly versatile. One 125 W-s unit lit the subject from camera right, and another lit the background. Both were elderly Courtenay units, bought secondhand. With low-powered flash, fairly wide apertures are necessary but this is not a problem with 35mm, which has inherently greater depth of field than larger formats. Exposure: f/4 on ISO 125 film (Ilford FP4).

150 W-s monobloc

Continuously variable 1200 W-s monobloc

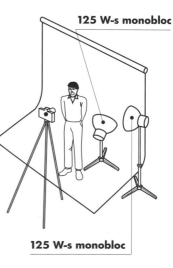

125 W-s monobloc

125 W-s monobloc

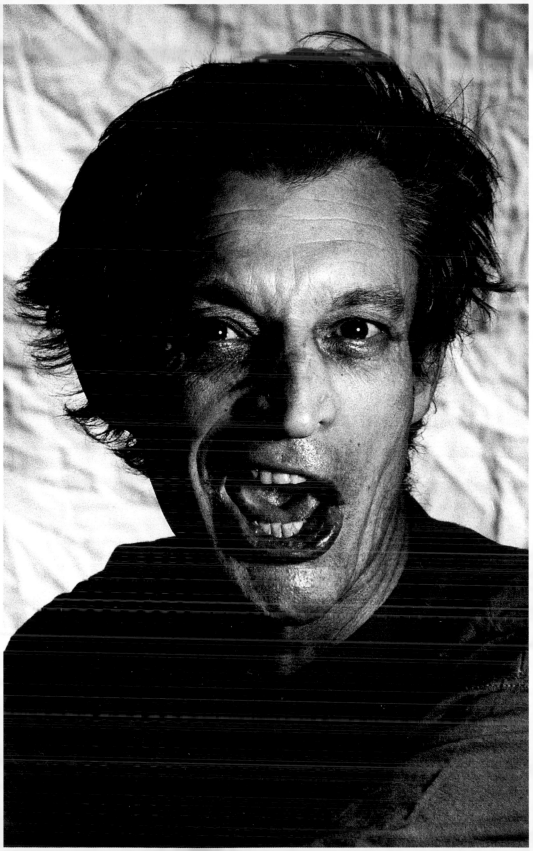

TECHNIQUES AND EQUIPMENT

Specialist Lighting

THERE ARE SEVERAL kinds of artificial light sources that are of limited use-fulness, alarming price, or both. Sometimes, though, they answer the question "How did they do that?" and some people may find these lights useful for a particular purpose.

The most easily affordable options are small ring flash, as described in the caption (below), and big bulb flash. Simple bulb guns like the one illustrated, from Micro Precision Products, are no longer available new but can be found cheaply at photo fairs and the like. Buy 3-cell (4.5-volt) units, because 2-cell (3-volt) units work only when the batteries are very fresh. For some kinds of location lighting of large subjects, such as civil engineering projects and speleology, they remain popular. A single, expendable bulb costs rather less than a roll of black-and-white film, and delivers as much light as a powerful monobloc electronic flash. One of the pictures on page 151 was lit with a big bulb flash.

High-frequency fluorescents are described in the caption (opposite) below the main picture. They are a refinement of the familiar fluorescent tube, but are much closer to a daylight spectrum. HMIs are another variety of high-frequency "cold" daylight-matched light and can deliver tremendous light outputs – a 10 Kw HMI can light up a city block – but they cost even more than high-frequency fluorescents.

Light brushes use an enclosed light source and a "light pipe," that brings the light to a "nozzle." In a darkened studio, the photographer "paints" the subject with light; a rather more advanced version of the trick shown on page 38. Needless to say, light brushes are expensive.

MPP bulb flash (RIGHT)

Ring flash (RIGHT)

Ring flash was originally designed for shadowless photography of cavities and crevices, especially in macro and medical photography. This is a low-powered, modestly-priced Centon, which can be mounted on lenses with filter sizes of 55mm and smaller. More powerful models from other manufacturers can be used for general photography. Ring flash is enjoying a revived vogue for photographing rock bands and musicians, as it is rediscovered by a new generation of young photographers.

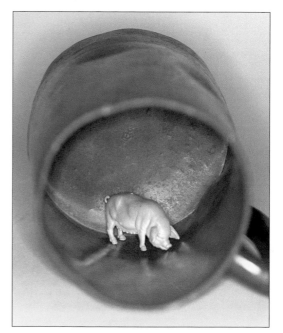

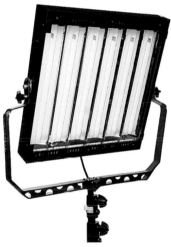

**Hancock's flicker-free
fluorescent** (BELOW)

Flicker-free fluorescents (ABOVE)

The main use of flicker-free fluorescents is in scanning digital photography, where flash cannot be used because of the long scan times. However, they are also useful for conventional photography when you want a continuous daylight source that can be continuously varied between maximum and minimum power; this obviates the mental gymnastics needed when mixing flash and daylight (see page 20). This state-of-the-art, remote-controlled high-frequency Hancock's light costs about the same as a monobloc flash head plus soft box, and delivers much the same kind of light. They are ideal for food shots, as they run cool, and the light quality is subtly different from a soft box unless they are diffused: with a diffuser panel in front, they are very similar to soft boxes, but with a big, silver-lined reflector they are somewhere between a flood and a trough, with a unique directionality of their own, as illustrated here.

**Hancock's flicker-free
fluorescent**

**Shaving
mirror**

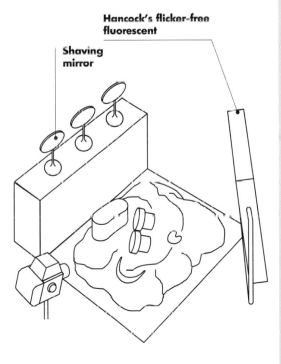

Close-up Lighting

Close-ups, copy lighting, and macro lighting all have their own requirements. For close-ups and macro, you often need quite a lot of light to compensate for the extra camera extension, and you may need cool light sources to avoid overheating the subject. For copying, the most important thing is evenness.

Longer-than-standard lenses allow you to work at a greater camera-to-subject distance, which in turn means more room to light extreme close-ups; this gives you extra room to maneuver the subject, camera, and lights. Ring flash (see page 48) has already been mentioned, but a cheaper option is to mount two low-powered flash units close to the lens on a simple bracket (which can be home-made).

Because the lights are close to the subject, they give enough light, and if there are two of them, you can use layers of diffuser, such as tracing paper, or turn one off, to vary modeling, which you cannot do with ring flash.

Modeling is the last thing you want in copying, so your lights must be equidistant from the subject, and at 45 degrees or more to the subject/camera axis. For relatively small subjects, up to about 8 x 12 in (20 x 30 cm), you can get away with two lights. For bigger subjects, four lights will allow you to get more even illumination more easily. If you are using low-cost electronic flash slave units, set everything up with tungsten lighting first, then replace the bulbs with the flash units.

Copying stand (RIGHT)
A ready-made copying stand, such as this one from Kaiser, or one adapted from an old enlarger, makes flat copying very much quicker, easier, and more reliable. Standard exposures can be established for each copy size.

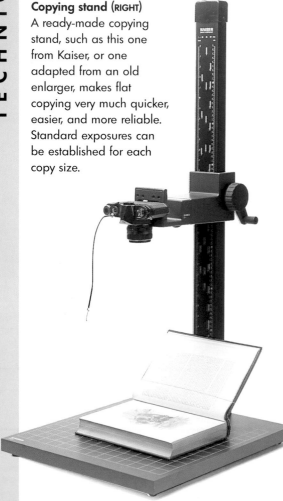

Even lighting for copying (ABOVE)
This image was "lifted" from a 19th-century book using a copy stand similar to the one illustrated and two Argaphot bulbs in broad (15 in/40 cm) reflectors. Rather than going to the trouble of making a negative and a print for reproduction, it was copied onto color slide film; a blue filter over the camera lens ensured neutral whites.

TECHNIQUES AND EQUIPMENT

Oblique lighting (RIGHT)

For small, textured subjects without much tonal variation, a glancing light from one side is necessary. These are pewter marks on a Scots charger (a variety of large plate) made in the late 18th or very early 19th century; the main mark is just over 1 in (2 cm) square. The charger was leaned against a box, with a flash head set alongside so that the light was just grazing the surface. The print was made on a contrasty grade of paper to emphasize the marks.

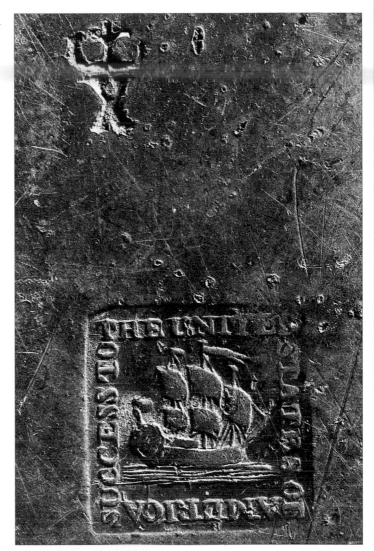

Flash

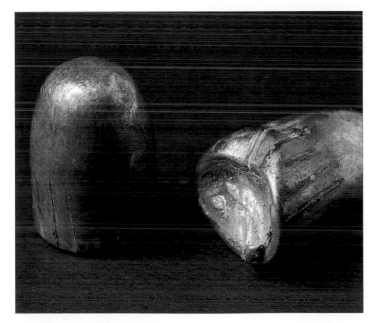

Extra lighting for extreme close-ups (LEFT)

For extreme close-ups, you need a great deal of light to compensate for the extra camera extension. These Colt 45 bullets were photographed at approximately twice life-size on 6x7 cm film. Indicated exposure (with an incident light meter) was between f/64 and f/90; actual exposure was f/22. The light was a 150 W-s unit with a standard reflector just 10 in (25 cm) from the subject at camera left, with a white bounce to camera right.

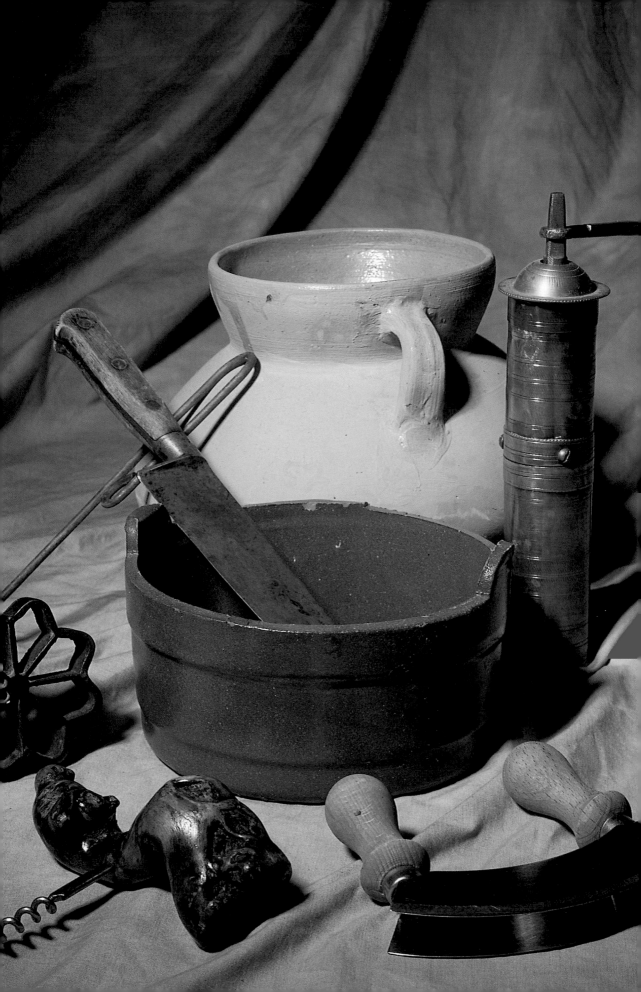

Modifying Light

Using Mirrors

Mirrors are of relatively limited use as conventional photographic reflectors because they are too directional and the light they reflect is too harsh. On the other hand, they are ideal as secondary "lights," precisely because the light they reflect is so hard.

Buy the cheapest shaving mirrors you can find. Cut at least one mirror into pieces: a flat edge makes it easier to lean a mirror against something and gives a sharper cut-off. Do not dispose of the other pieces; even quite tiny fragments can have their uses. Thin shaving mirrors are much easier to cut (with a glass cutter) than thick mirror tiles, and the edges are less sharp. "Swipe" the cut edges with a piece of emery cloth to blunt them. Concave (magnifying) mirrors should be left whole to focus light.

Lean the pieces of mirror against things; hold them with modeling clay, duct tape, and large clips; or improvise and buy miniature "gaffer" systems to hold them in place. The system illustrated is made by Climpex; a full kit is quite expensive, but immensely versatile.

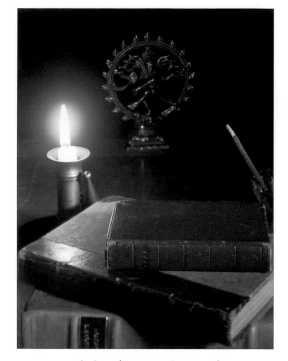

Mirrors as "lights" (ABOVE and OPPOSITE)
The picture above is lit by the candle and an electronic flash to camera right. In the picture opposite, two mirrors have been added to camera left: one to lighten the spine of the middle book in the stack, the second to add roundness to the candlestick, reducing the impression of external lighting. The advantage of the second mirror is less clear than with the first; an important point is knowing when to stop. Both mirrors reflect the light from the flash, not the candle.

Mirrors (ABOVE)
The three small make-up/shaving mirrors cost little new, and the taller mirror was only slightly more expensive in a junk shop. The Climpex stand holds a cheap, cannibalized shaving mirror.

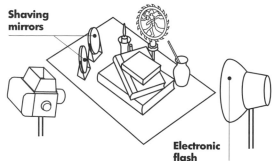

Shaving mirrors

Electronic flash

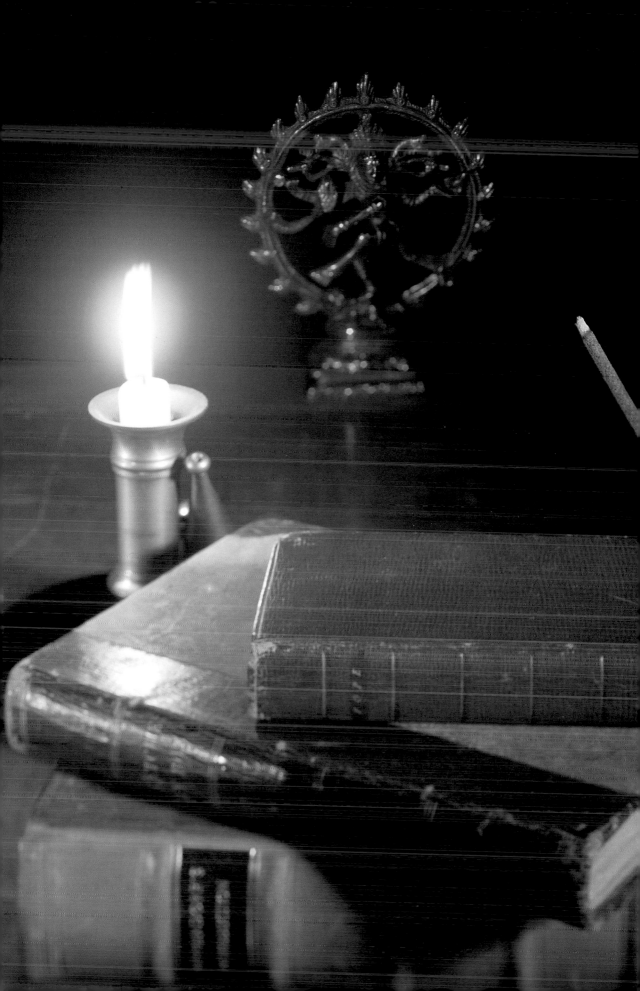

TECHNIQUES AND EQUIPMENT

Bounces and Diffusers

LIGHT CAN BE softened by diffusion – think of sunlight through thin curtains – and by reflection or "bouncing": think of sunlight reflected off light-colored walls.

Diffusers go between the light source and the subject; a popular material to use is white nylon. Any translucent material will do, though colored diffusers will color the light. All diffusers reflect, as well as transmit, light; if they transmit much more than about half the light falling on them, they are unlikely to provide enough diffusion.

Bounces (reflectors) are normally used on the far side of the subject from the main light in order to reflect some light back to act as a fill. They are often placed surprisingly near the subject, just outside the field of view of the camera; move the bounce nearer or further away, and vary its angle to the light, to see what difference it makes.

Bounces are typically made of white nylon which reflects about 40 to 60 percent, depending on the weave. A reflector woven with metallic thread can reflect considerably more light, though beyond a certain point it becomes too "hot" and starts acting more like a mirror than a diffuse reflector.

Colored bounces will color the light: gold fabrics are often used to warm the light. A specialized bounce is the "black bounce" (see opposite), which is used to absorb light rather than to reflect it. If stray light is reflected back into a shot, a black bounce will often solve the problem.

Lastolite white bounce

Lastolite silver bounce

Homemade bamboo frame

"Scrim Jim" diffuser

Lastolite collapsible frame

Bounces and diffusers (ABOVE)
Bounces (reflectors) create fill and diffusers soften the available light. Bounces and diffusers can be made easily; the bamboo-framed bounce shown above was made with gardening poles, florists' wire, and cheap white nylon fabric.

IMPROVISATIONS

Bounces can be as simple as sheets of white cardboard, white fabric, or white-painted wood. White expanded poly-styrene is light, cheap, and highly reflective, or you can crumple a sheet of aluminum foil, smooth it out again roughly, and then glue it to a sheet of hardboard or cardboard. To make a combination bounce/diffuser, stretch thin white nylon over a light, rigid frame of bamboo or something similar.

TECHNIQUES AND EQUIPMENT

Natural light plus bounce
(RIGHT)
The only light in this church came from the windows, especially those behind the lectern. A big white bounce (5 feet/1.6 meters square), just in front of the camera, lightened the highly reflective lectern; no additional lighting was used. Exposure: 30 seconds at f/16 on ISO 125 film (Ilford FP4 Plus).

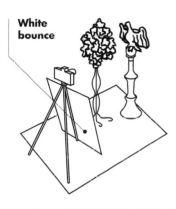

White bounce

USING A BLACK BOUNCE

The idea came from a shaft of sunlight casting this long, rather sinister shadow. From there, it was a short step to setting up a picture of the pig "hunting" the money; the light is from a slide projector. The pig's shadow was, however, weakened by light reflected back from outside the set, so a black bounce was used to absorb the stray light and intensify the shadow. Exposure: 10 seconds at f/16 on ISO 125 film (Ilford FP4 Plus).

Black bounce

Slide projector

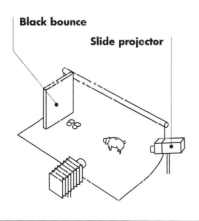

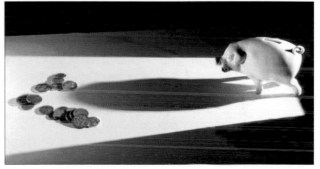

Without black bounce

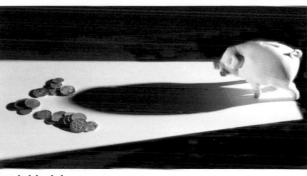

With black bounce

Scrims, Flags, and Gobos

SCRIMS, FLAGS, AND GOBOS are extremely useful weapons in the photographer's lighting arsenal. Unfortunately, the terminology is very confused.

The word "scrim" is used to mean two things. One is a thin, light piece of fabric placed between the light and the subject to reduce the intensity of the light and soften it slightly, without diffusing it very much. Although usually made from a black net-like material, white scrims (which soften the light more) are also used. The word "scrim" also describes a rather thicker white fabric that is draped over a light to soften it. This sort is often made of woven fiberglass, in order to be heatproof.

A flag, also known as a French flag, simply blocks off the light. It can be as simple as a sheet of cardboard, or a sheet of wood or metal. Flags are often black on one side and white (or polished) on the other, so they can also be used as bounces.

Flags are also known as gobos, though some people reserve this term for flags with holes in, which are used to create dappled light; but these are also known as "cookies" to yet other people. And "gobo" is also used to describe a metal mask used in a projection spot to cast a clear shape. The interrelationships are clear enough, but the terminology is certainly muddled!

Flags, scrims, and gobos (BELOW)

Clockwise from top left: a gobo improvised from a piece of black aluminum foil (available from Lee or Rosco), a Lastolite collapsible scrim frame with a black nylon flag, another Lastolite frame with a #3 scrim (the edges are color-coded, with #3 being the strongest), and the sheath from a 4 x 5 in (10 x 12.5 cm) dark-slide used as a small flag. Everything is held together by clamps from Climpex.

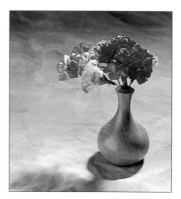

Flash alone

Using flags and gobos (ABOVE and RIGHT)

Without any modification (above), the lighting is pleasant enough but dull. Adding a flag to blank off the background makes the flowers stand out more, but overdarkens the background (bottom right). Replacing the flag with a gobo gives just the right balance of light and dark, creating an attractive dappled effect (top right). The single honeycombed flash head (see page 62), is set high and to camera right, backlighting the subject. Exposure: f/16 on ISO 100 film (Fuji Astia).

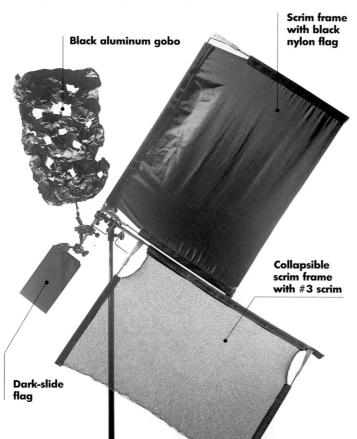

Black aluminum gobo

Scrim frame with black nylon flag

Collapsible scrim frame with #3 scrim

Dark-slide flag

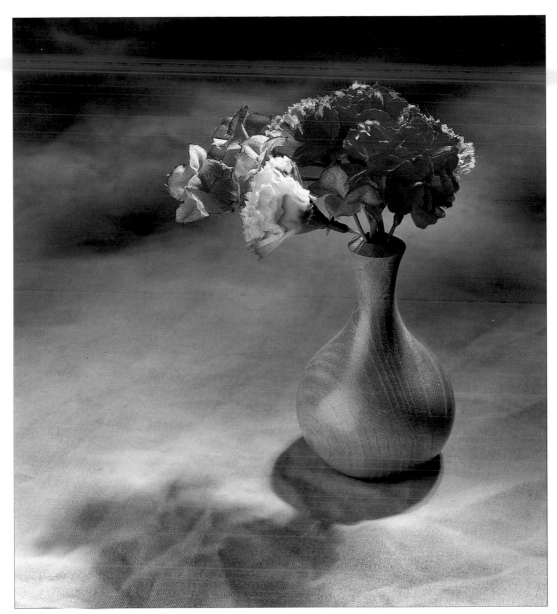

Flash with gobo

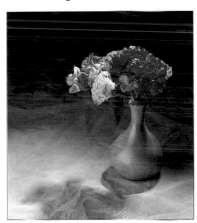

Flash with background flagged

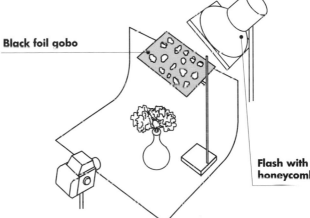

Black foil gobo

Flash with honeycomb

TECHNIQUES AND EQUIPMENT

Reflectors and Barn Doors

THE QUALITY OF light from tungsten or flash or anything else can be greatly modified by the use of different shapes, sizes, and finishes of reflector. Deep, highly polished reflectors cast an intense beam, like vehicle headlights, while shallow, matte reflectors give a much softer light. If barn doors are fitted – the term is self-explanatory once you have seen them – then you can flag off light from where it is not wanted.

The smallest reflectors, sometimes known as "spill kills," do little more than stop the light spilling sideways from the light source, though highly polished interiors can make for a strongly directional light. Spill kills are typically 8–10 in (20–25 cm) in diameter, and are pretty much the standard reflectors for flash. The next size up, 10–14 in (25–35 cm) in diameter, is generally regarded as the standard reflector for tungsten lighting. Still larger reflectors (16–20 in/40–50 cm) often have a removable cap over the bulb to avoid "hot spots." These are the usual way to get soft light from a tungsten lamp.

As for barn doors, although you can get two-door versions, the best are almost always four-door, with two opposite doors tapered to allow adjacent doors to be used together.

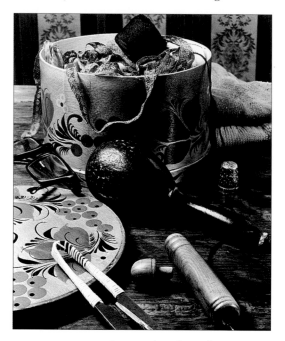

Sewing box (ABOVE)
Combining a big reflector – a 16-in (40-cm) "bowl and spoon" – with a white-painted interior creates a "beauty light." Although clearly directional, the light is broad and soft – ideal for a nostalgic still life of an old-fashioned subject.

Reflectors and barn doors (LEFT)
From the left: flash head with barn doors; tungsten head (Interfit) with 8 1/4-in (21-cm) spill kill reflector; tungsten head with 16-in (40-cm) "bowl and spoon" reflector (the removable bulb cap is the "spoon" in the "bowl").

The effect of reflectors (BELOW)
The smallest reflector gives the hardest light and the deepest shadows; the medium-sized (12-in/30-cm) reflector is softer, and the big white-painted reflector is softer still, and can be softened further by adding the bulb cap. In order of brightness, the small spill kill and the 16-in (40-cm) "bowl and spoon" are almost equal; the 16-in (40-cm) reflector without the cap is about a stop brighter; and the 12-in (30-cm) reflector is about half a stop brighter again.

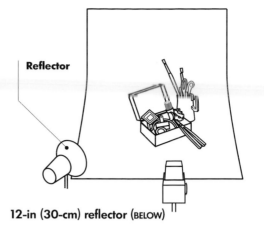

Reflector

10-in (25-cm) reflector (BELOW)

12-in (30-cm) reflector (BELOW)

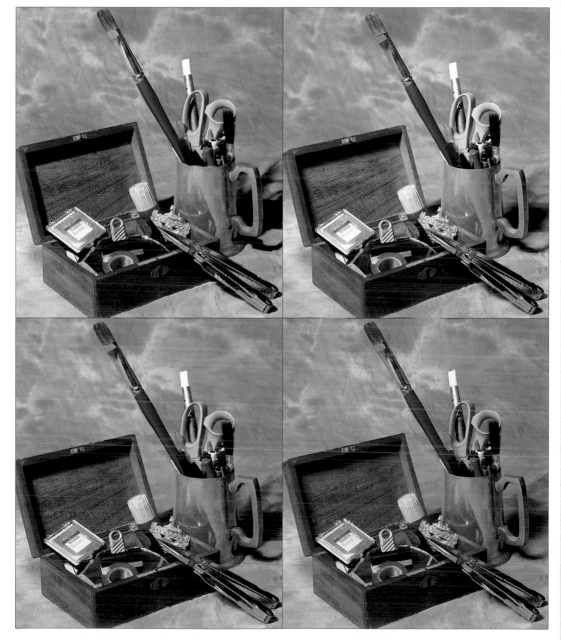

16-in (40-cm) white-painted reflector (ABOVE)

White-painted reflector with bulb cap (ABOVE)

TECHNIQUES AND EQUIPMENT

Snoots and Honeycombs

SNOOTS AND HONEYCOMBS are both ways of controlling the spread of light and making it more directional. They are used far more on electronic flash than on tungsten, partly because focusing spots are a rare breed in flash, and snoots and honeycombs help redress the balance, but also because snoots, in particular, soon get very hot indeed on anything more than a modest tungsten light.

The most convenient snoots are factory-made, but it is perfectly possible to improvise snoots from cardboard or (better still) from black aluminum foil. You can wedge them onto a standard reflector, or use duct tape, though the latter tends to go sticky and nasty if it is left on too long.

Honeycombs, sometimes known as grids, are a by-product of the aerospace industry; the honeycomb-shaped cells form the middle layer in very strong, very light bonded composites. Happily, they also increase the directionality of light very efficiently. Most manufacturers offer two (sometimes more) sizes: the smaller the honeycomb size, the tighter the light beam.

Snoots and honeycombs may be fitted direct to a lighting head but more often they are fitted to one of the reflectors in the manufacturers' range. As well as being useful for still lifes, as illustrated, they are invaluable for hair lights and other effects lights in portraiture.

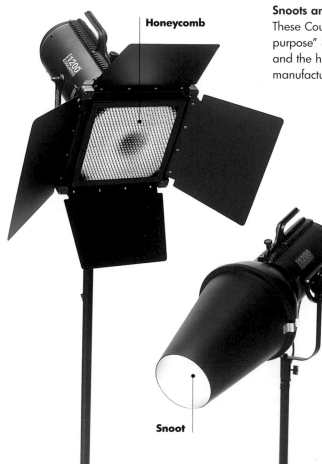

Honeycomb

Snoot

Snoots and honeycombs (LEFT)
These Courtenay lights both fit onto "general purpose" 8-in (21-cm) reflectors, the snoot directly and the honeycomb into the barn doors; other manufacturers may use other arrangements.

Using snoots (RIGHT)
A snoot reduces light output more than a honeycomb, but gives a harder edge to the light when used reasonably close to the subject. It also costs less than a honeycomb. The hard edge is used here to differentiate the two sides of the helmet (the right is light against dark, the left is dark against light); with a plain reflector, the helmet could easily have been "lost" against a bright and rather plain background.

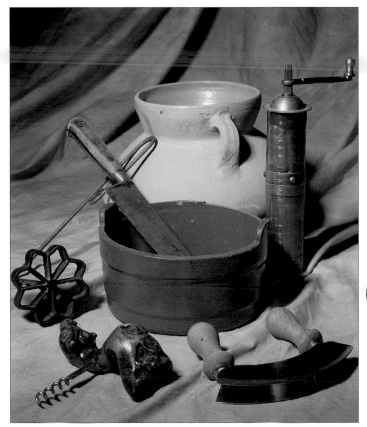

Using honeycombs (LEFT)

Using a plain reflector, the background in this still life was too bright. The honeycomb narrowed the beam of light and sharpened the shadows but still gave a reasonably soft perimeter to the pool of light.

Honeycomb

Umbrellas and Soft Boxes

UMBRELLAS AND SOFT boxes are the exact opposite of reflectors, barn-doors, snoots, and honeycombs: instead of restricting light and making it more directional, they make it softer and more diffuse.

Umbrellas come in two varieties: shoot-through and reflector. They can be used both with tungsten and with flash. A shoot-through umbrella is effectively a convenient way to use a diffuser, and (as with all diffusers) light losses tend to be quite large; the reflected light can also create a lot of "spill."

Reflector umbrellas are a cross between a lamp reflector and a bounce. Although they generate less spill than shoot-through umbrellas, they still leave some light uncontrolled. Most umbrellas are 36–48 in (90–120 cm) in diameter.

Soft boxes are both more efficient and more controlled than umbrellas. Far more of the light goes where it is wanted, through the diffuser panel, and little or none escapes sideways. Most are lined with silver fabric to increase their efficiency and have a secondary (removable) diffuser between the light source and the main diffuser; most can also be used without any diffuser, as a large reflector. Sizes vary widely, from as little as 12 in (30 cm) square to 40 x 60 in (100 x 150 cm) and indeed bigger. They are more common with flash than with tungsten because of heat build-up.

Soft box (BELOW)
Soft boxes range from 12-in (30-cm) square up to 7 x 10 feet (2 x 3 meters) and bigger. Anything smaller than 27-in (70-cm) square (as below) is often too close in size to a standard reflector, while anything larger than 40 x 60 in (100 x 150 cm) can be unwieldy and needs a lot of power.

Umbrella (BELOW)
"Shoot-through" white nylon umbrellas are often the first type bought by amateurs, and make excellent fill lights while a "bounce" umbrella makes the most of the light available – if you have two heads, buy one of each.

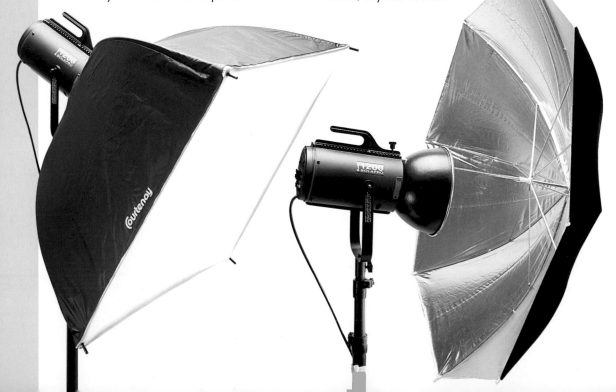

Product shots (ABOVE)

Soft boxes are the usual lighting for pack and product shots, and after a while you almost instinctively notice the characteristic reflections and highlights that they produce; look at the "shoulders" on the bottles and the diffuse shadows. This was shot with a 40 x 50-in (100 x 120-cm) soft box with a 1200 W-s head; the diffuser was about 20 in (50 cm) above the subject. Exposure: f/16 on ISO 100 film (Fuji Astia).

Flash in soft box

Umbrellas and reflections (ABOVE)

Clearly reflected umbrellas can be painfully obvious. With the reflection visible all the impact of an evocative travel picture is lost. Re-angling the sunglasses would have easily avoided the problem.

TECHNIQUES AND EQUIPMENT

Polarized Light

MOST OF US ARE familiar with using polarizing filters as a means of reducing reflections and deepening blue skies, and many will have seen how, if you cross two polarizers, they block out almost all the light. Rather less familiar, though, is the idea of using polarizers on the light sources as well as on the camera.

There are numerous applications, but most of them turn on the fact that if the light source is polarized, and there is also a polarizer over the camera lens, you can eliminate reflections, even with difficult subjects such as oil paintings, where "flashback" and loss of contrast are perennial problems.

The other intriguing application of polarized light is to shoot transparent or translucent plastic objects between two polarizers. Any stress in the plastic will vary the polarization of the light, resulting in unique and often spectacular birefringence – double refraction – patterns as illustrated.

POLARIZING FILTERS

Polarizing filters for camera use are available from many sources; the main thing to watch out for is that some cheap filters have a greenish or brownish tinge, instead of being neutral in color. Larger sheets of polarizing material for use in front of lights are harder to find, and are also more expensive.

Birefringence (RIGHT)
These spectacular effects were obtained simply by placing a sheet of polarizing material behind the subject (part of a cheap school geometry kit) and a polarizing filter on the lens, then rotating the two until the most dramatic colors appeared. The subject is, of course, transilluminated. A high-saturation film, such as Fuji Velvia, will emphasize the effect.

Working with crossed polarizers (BELOW)

The first picture uses no polarizing screens. The second uses a polarizing filter on the camera lens, but not on the light. The third uses a Light Stuff polarizing screen on the light and a filter on the camera lens. Although the handle of the Swiss Army knife is deep red, the overall effect is unnatural because even the reflections on the metal highlights have been suppressed (this is impossible without two polarizers). The fourth picture uses a polarizer on the light and the camera, but a small amount of reflection has been allowed to remain, for an effect that is both convincing and highly saturated in color. The key light on the left is unaffected by the polarizer – it is reflecting unpolarized light from a white bounce to camera left. The exposure varied according to the filtration used.

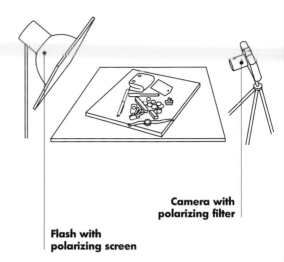

Camera with polarizing filter

Flash with polarizing screen

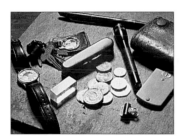

No polarization

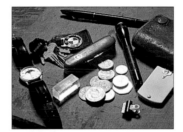

Polarizing filter on camera

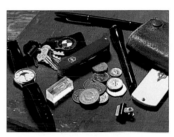

Polarizing filter and screen

Polarizing filter and screen, with some reflection retained

TECHNIQUES AND EQUIPMENT

Measuring Light

Metering

Flash Meters

Metering

ALL METERS THAT measure reflected light are based on the assumption that an "average" subject will reflect an "average" amount of light. Unusually dark subjects may therefore be represented too light, as the meter tries to bring them back to "average," and unusually light subjects may be represented too dark.

With an in-camera meter or a hand-held reflected-light meter, light subjects therefore require extra exposure (typically up to two stops) while dark subjects require less exposure (typically around one stop). Modern multi-sector in-camera meters are designed to compensate for this to some extent, but even they can sometimes be "fooled."

The light meters built into most 35mm SLRs and roll-film cameras are designed to give optimum exposure with slide films, where the exposure is pegged to the highlights, but when using black-and-white film, it is often best to give half a stop to a stop more than the meter recommends, in order to favor the shadows.

Most professionals use incident-light meters, which measure the amount of light falling on the subject. With these, at least corrections can be easily made in the most intuitive direction. Unusually dark subjects require a little extra exposure to lighten them, and unusually light subjects require a little less exposure to darken them. A useful technique with tricky subjects is a "duplex" reading. Read both reflected light and incident light, and split the difference.

Another "duplex" technique, which is especially useful with backlit subjects, is to take two incident light readings from the subject position. Point the meter at the camera and at the key light. Again, split the difference. This will give you the best possible compromise.

Never be afraid to depart from the meter reading. If your pictures are consistently light or dark, reset the ISO film speed. If you want a light, airy mood, give up to a stop more exposure than indicated; for a dark, brooding effect, cut exposure by up to a stop.

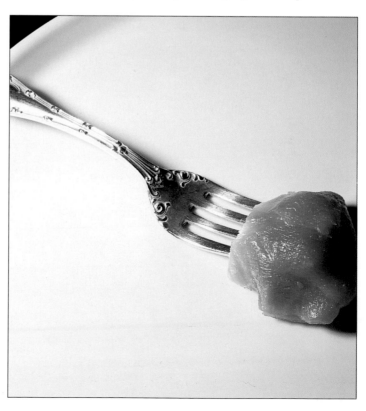

Smoked salmon on a white plate (ABOVE and RIGHT)
A multi-sector through-the-lens meter agreed with an incident-light meter (and with the correct exposure) to within 1/3 stop for the white plate (right), though a simple center-weighted through-the-lens meter recommended almost 1 stop of under-exposure (above).

BRACKETING AND SPARES

Because films do not "see" in exactly the same way as the human eye, giving a little more exposure than is indicated by the meter, or a little less, may create an effect that is closer to what we visualized. Also, bracketing is useful and cheap insurance against mistakes; if you have gone to some trouble to set up and light a picture, it is well worth both bracketing and shooting "spares" or extra pictures at each exposure.

Out of doors, one-stop brackets above and below the meter reading are often perfectly adequate, but in the studio, smaller brackets are often appropriate. With a forgiving film such as Fuji Astia, 2/3 of a stop is fine, but with a critical film such as Fuji Velvia, 1/2 a stop or even 1/3 of a stop may be appropriate.

Weston Master V (ABOVE)
Selenium-cell meters need a big photogenerative cell for reasonable sensitivity, and even then are less sensitive than photo-resistive meters (CdS and silicon blue). The big cell also means that they have a wider angle of acceptance. They do, however, have the advantage of needing no batteries.

Gossen Lunasix 3 (ABOVE)
An old favorite – this one's almost 20 years old, as may be clear from its state. With its tiny numbers and rather slow-responding cadmium-sulphide (CdS) cell, it is now becoming rather outdated.

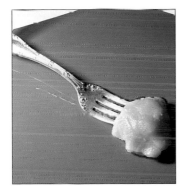

Smoked salmon on a black plate (ABOVE and RIGHT)
On the black plate, the reading from the multi-sector meter resulted in two stops underexposure, while the simple center-weighted meter was 1 1/2 stops under (above). Once again, the correct exposure (right) was indicated by a separate incident-light meter.

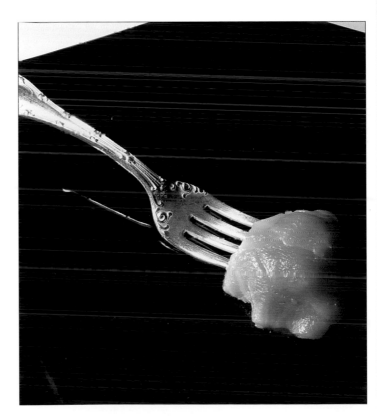

TECHNIQUES AND EQUIPMENT

Flash Meters

IN-CAMERA METERS CAN handle "dedicated" flash, because they control the exposure by controlling the light output of the flash; but they cannot do this with studio flash. Although purpose-made flash meters are not cheap, the lower-priced models can pay for themselves in materials saved. Besides, what price do you place on peace of mind and better pictures?

If you do not already own a conventional hand-held exposure meter, it may well be worth considering a combined ambient light/flash meter. The simpler models assume a constant shutter speed (usually 1/60 second) and give a flash-plus-ambient reading based on that; more sophisticated models take account of shutter speed and can even give two simultaneous readings, one for flash and one for the background ambient light. Many can add together multiple flash "pops" made one after the other.

For color negative or black-and-white photography, especially with roll- or large-format film, a flash reading to the nearest stop is adequate, and a reading to the nearest half-stop is more than adequate; err always on the side of over-exposure. For color slide, readings to the nearest 1/3 stop or better are more desirable, though you can always bracket.

Gossen Lunasix F (BELOW)
The Gossen Lunasix F reads either ambient or flash light with a highly accurate null-reading system, while still showing all possible combinations of aperture and shutter speed.

Gossen Variosix F (ABOVE)
The Gossen Variosix F gives a digital reading to the nearest 1/10 stop (which is more accurately than you can set most cameras and flashes) and allows both ambient light and flash readings to be taken simultaneously, for a wide range of shutter speeds.

Courtenay Flash Meter 3 (ABOVE)
The Courtenay Flash Meter 3 gives flash readings to 1/3 stop resolution; models 2 and 1 give 1/2 stop and 1 stop respectively. The all-solid-state circuitry, with LED readouts, is typical of modestly priced flash meters.

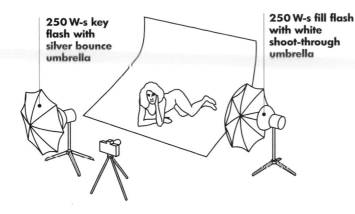

250 W-s key flash with silver bounce umbrella

250 W-s fill flash with white shoot-through umbrella

Nude (BELOW)
Two 250 W-s flashes were used for this picture, the key bounced from a silver umbrella to camera left and the fill put through a white umbrella to camera right. Trying to calculate this sort of exposure is impossible without a flash meter. Exposure: f/5.6 on ISO 400 film (Ilford HP5 Plus).

TECHNIQUES AND EQUIPMENT

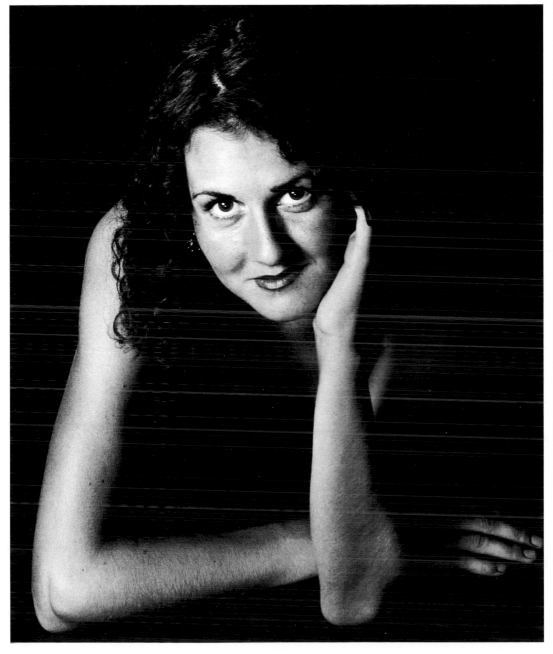

Spot Meters

SPOT METERS ARE often held up as the ultimate in metering. To some extent this is true, as they allow you to measure tiny areas of your subject for maximum precision. But you do not always need that degree of precision, and deciding which areas to meter can require a good deal of thought. They are best used as a supplement to other meters rather than on their own. The best can measure both flash and ambient light.

Gray cards are also touted as a panacea, and they are a lot cheaper than spot meters, but to use them you still need understanding and experience. You can meter gray cards with most modern hand-held meters, provided you take care not to shade the card with the meter as you do so; a spot meter, of course, makes metering gray cards easy, but it is all too easy to forget the card and leave it in shot. Readings from grey cards will give similar results to incident light meter readings, but by angling the card you can check lighting ratios.

Spot meter and gray card (RIGHT)
The Gossen Spot Master 2 (right) is big and heavy, but strong and highly accurate, and the five-button controls are easier to master than some spot meters which have over a dozen buttons. This wipe-clean plastic gray card from Paterson folds like a menu and has one side 18 percent gray and the other side (not seen) white with 90 percent reflectance. You can see from the different tones of the two halves of the card that a lot depends on where you place the card and how you angle it.

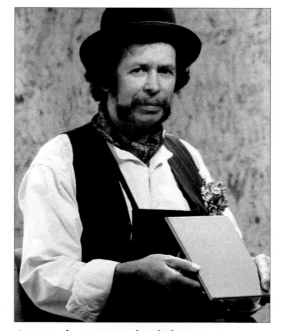

Gray card pointing at camera **Gray card pointing at key light**

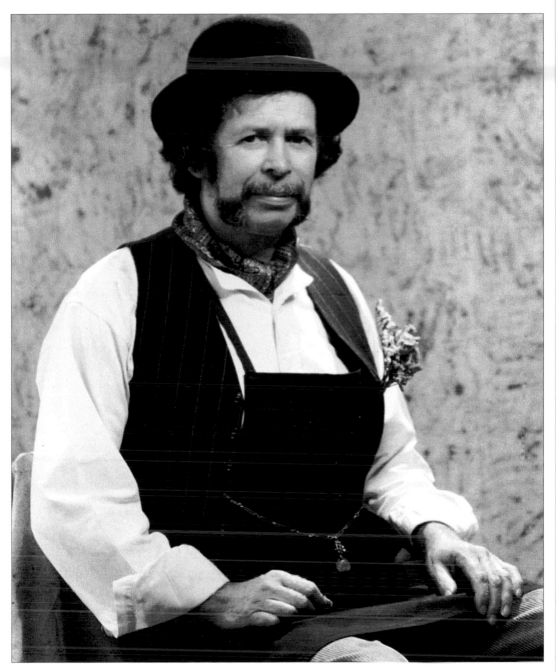

TECHNIQUES AND EQUIPMENT

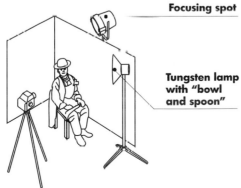

Focusing spot

Tungsten lamp with "bowl and spoon"

Portrait (ABOVE)

The two small pictures (opposite) show the inherent problem with a gray card: its brightness varies depending on where you hold it. The two spot readings were $1/30$ second at f/8 and $1/30$ second at f/4.8 ("f/4 and a half"). The exposure chosen for the portrait (above) was $1/30$ second at f/5.6), in order to emphasize shadow detail.

TECHNIQUES AND EQUIPMENT

Polaroid Testing

THE ULTIMATE IN exposure control is Polaroid testing, when you make an instant picture on Polaroid material before taking the final shot. Most professionals make Polaroid tests as a matter of course, and although they are expensive, there is nothing to beat the peace of mind they can bring.

Some 35mm cameras, most medium-format cameras, and all conventional 4x5 inch and 8x10 inch cameras can be fitted with Polaroid backs. If the cameras have interchangeable backs, you can often interchange Polaroid and conventional backs freely without losing a single exposure. Polaroid backs can be reasonably cheap and

you have only the cost of the materials to worry about. With cameras that do not have interchangeable backs, it is easiest to dedicate a body to the Polaroid back. This can be very expensive, as a Polaroid back for a Pentax 6x7 cm, for example, costs about the same as a camera body.

All Polaroid backs use the old-style peel-apart materials, rather than the modern "integral" materials, as they develop faster and more predictably and are available in a wide range of emulsions. The two most popular are ISO 100 monochrome and color films, in either "pack" sizes (8 or 10 sheets to a pack, used for 35mm and medium-format cameras) or 4x5 inch single sheets.

BUILDING A POLAROID TEST CAMERA

In order to make a meaningful Polaroid test, you need controllable apertures and shutter speeds, and a flash-synchronized lens. You can make a usable Polaroid test camera by gluing a modestly-priced Polaroid CB-103 film holder, the same basic unit that manufacturers' custom backs use, onto a cheap, old medium-format camera body. You do not need to be a skilled craftsman to make such a camera: "cut and try" is quite adequate, and the camera shown was built with a Swiss Army knife, some fine sandpaper, and epoxy adhesive. Check the register with a piece of ground glass held in an empty Polaroid film pack holder.

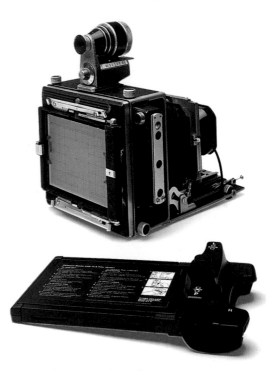

4x5 inch camera (ABOVE)
This camera is an MPP Mk. VII dating from the 1960s. The Polaroid back, a 545i, takes single sheets of film and slips under the ground glass like a regular cut-film holder.

Polaroids (ABOVE)
The big Polaroids are 4x5 inch. The smaller 6x7 cm images have to be masked to show the final crop. The tiny Polaroid is from a 35mm camera: even a 1x1-1/4in (24x36mm) image can tell you a surprising amount.

6x7 cm camera

6x7 cm camera (LEFT)
This "baby" Linhof Super Technika IV is of similar vintage to the MPP and takes its own unique-fitting Polaroid film holder for quarter-plate film (3-1/4x4-1/4in/83x108mm).

Polaroid back

Ground-glass back

Roll-film back

Setting up
a Studio

Sets and Backgrounds

Backdrops

Hired Studios

A Studio of Your Own

Sets and Backgrounds

A STUDIO – A PERMANENT place for taking pictures – is the ultimate aspiration of many, but before you get too carried away with the idea, it is worth remembering two things. The first is that many professionals prefer to work on location rather than in the studio, simply because a real setting generally looks more authentic than a studio. The other is that it is possible to set up certain areas of your house as a "studio" while still retaining their usefulness in everyday life.

When you refit a kitchen, for example, you can do so with an eye to photographic possibilities as well as general function, and in a bedroom or a drawing room you can do much the same. There are, however, two important things to watch out for.

One is backgrounds. In particular, take good care to route all cables out of sight, and not to have electrical sockets in prominent positions.

The other is wear and tear. The slightest shabbiness will normally be emphasized by the camera, and something that would never be noticed in real life can make a location look very unappealing. The best way around this is to choose objects and materials that will wear gracefully and acquire "character" as they age.

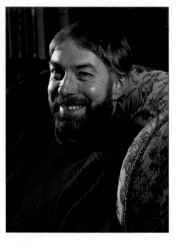

Stove (RIGHT)

Many photographers furnish and decorate their houses with photographic possibilities in mind. This Victorian stove not only fits in with our lifestyle and our 19th-century farm-style kitchen (also seen on page 144); it is also a valuable prop in its own right. Here, we contrasted it with two pans, again bought for their visual appeal as well as for use: the stainless-steel asparagus cooker and the orange frying pan. Exposure: 1 second at f/11 on ISO 100 film (Fuji Astia), mixing daylight and flash.

Dave Barber (ABOVE)

A soft box to camera left acts as the key, plus a snooted spot to camera right. By changing the lighting and restricting depth of field, attention is concentrated on the subject's face. Although the background is out of focus it was specially chosen for its subtlety and interest. Also, the books have been "gardened" to weed out any jarringly bright spines.

500 W-s flash

NATURAL LIGHT AND
ARTIFICIAL LIGHT

With south-facing rooms particularly, it can be difficult to exclude the effect of daylight. Heavy curtains help, and you can buy blackout material which can be pinned to existing curtains or clipped to curtain rails or pelmets with clips, or used to line existing curtains. This material is fairly expensive but is obtainable from shops specializing in curtains, as well as from some photographic dealers.

Backdrops

THE FIRST MAJOR step towards "studio" work is arguably the acquisition of backdrops. Almost anything can be used as a backdrop, and many photographers keep their eyes open for ideas at all times, but there are two particularly important kinds: seamless paper and fabric.

Seamless paper backdrops are sold as big rolls, typically 9 feet (2.8 meters) wide and up to 100 feet (30 meters) long. "Half rolls" are 4 feet 6 in (1.4 meters) wide and can be bought that size, or cut down from full rolls, which works out much cheaper per roll. By appropriate lighting, a single color can be made lighter or darker, which allows a good

deal of flexibility. White is the most useful color, followed by either black or thunder gray, with your favorite colors next.

Fabric backgrounds can be bought in a variety of sizes from a number of manufacturers, or they are surprisingly easy to make. The fabric can be heavy muslin, or sheeting, or (cheapest of all) decorators' drop cloths, available from builders' suppliers. Some photographers paint these with latex-based paints, which creates backgrounds that have to be rolled fairly carefully, while others use fabric dyes. Many of the portraits in this book, and some of the still lifes, were shot against home-made backgrounds.

HOME-MADE BACKDROPS

All these backdrops were home-made, using fabric dyes and either decorators' drop cloths or (for the deep rose background) yardage. They are supported on a proprietary background support system, though you can also make your own supports from wood, or from a couple of lighting stands bridged with a piece of light, rigid plastic drain-pipe. Exposure: $^1/_2$ second at f/11 on ISO 100 film (Fuji Astia), using a single diffused tungsten light.

Creating mood with backdrops (OPPOSITE)
The mood of these two pictures is very different. One uses plain white background paper (often known as "Colorama," though this is the trade name of a leading brand) and is somewhat clinical. The other uses a home-made backdrop, with the back graded almost to darkness (page 104). The over-prominent crease line in the one with the colored background shows why it is a good idea to "stuff" or "crush" these backgrounds instead of trying to fold them neatly. This shot was taken using an electronic flash in a soft box positioned overhead.
Exposure: f/22 on ISO 100 film (Fuji Astia).

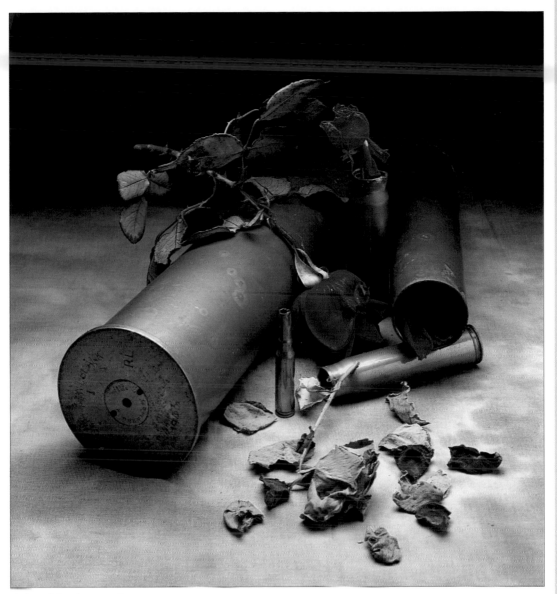

Colored background

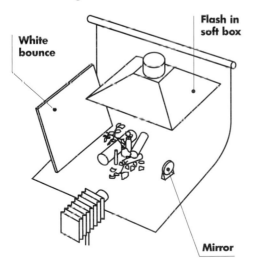

White bounce

Flash in soft box

Mirror

Plain white background

Hired Studios

MOST PEOPLE LACK the space to set up a studio at home, and even if they have the space, they may well have other priorities. It is, however, possible to borrow or hire studio space.

The cheapest way is usually to hire a large space that is not specifically designed as a studio. Church halls, scout huts, even community theater stages provide large, unencumbered spaces with high ceilings. If you are a smooth talker, you may be able to borrow the space in return for taking pictures for publicity purposes. Look for easy blackout (which need not be absolute); for changing space for models; for enough heat to work (important in the depths of winter); and for adequate power supplies.

It can also be surprisingly straightforward to hire a proper studio; look in the Yellow Pages and the small ads in the photographic press, or call around local photographers. Some lights and other equipment may be supplied or may be available for an additional charge. Amateur-oriented studios are normally set up for nude photography, but they can often be adapted for other uses, while professional studios are available in many sizes, up to and including those that will hold a bus. Some professional studios also offer processing facilities.

TIME AND MONEY

Although some studios quote hourly rates, it is rarely worth bothering with less than half a working day or a whole evening. Allow at least an hour on top of your estimated shooting time, to set up and strike your sets. Better still, two extra hours will give more latitude with models who turn up late and for other problems. You may sometimes be able to get substantial discounts (50 percent or more), especially from professional studios, if you book for slack periods or at times when no one else wants the place. Always establish clearly what is available and what is included in the price, and use checklists to make sure you have everything that you need for a particular shoot.

Photography club nights
(RIGHT)

Even if you have your own lighting equipment, a photographic club night can give you access to large shooting spaces and models. Large spaces "eat" light, and amateur flash is often not very powerful anyway, so the exposure was f/8 even with ISO 800 film rated at EI 400 to capture detail in the black silk.

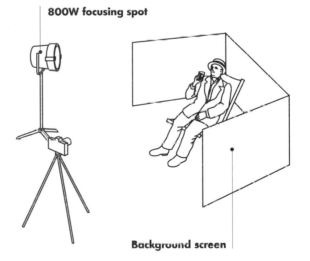

800W focusing spot

Background screen

Tony (LEFT)

This shot was taken in a large hall, which allowed the single 800W focusing spot to be set some distance from the subject, creating the impression of sunlight (tungsten light on daylight film mimics the setting sun). This, though, necessitated a long exposure; the model was made aware of this – holding a pose for $1/15$ second is not difficult, though holding a camera still for this length of time definitely requires a tripod. Exposure: $1/15$ second at f/5.6 on ISO 800 color negative film (Kodak Multispeed).

A Studio of Your Own

IF YOU HAVE the space, there is nothing so convenient as a full-time studio. Unfortunately, it needs to be pretty big. You can shoot small still lifes in a room as small as 10x13 feet (3x4 meters), but you will be severely constrained as to where you can set your lights. The minimum for any versatility at all is 13x16 feet (4x5 meters), and even then, you will not be able to get back very far for shooting portraits.

As with floor area, so with ceiling height. If you want to use overhead lighting, the minimum ceiling height is about 9 feet (2.8 meters); 10 feet (3 meters) is needed for comfort. This unfortunately rules out many garages and most basements.

You will need generous supplies of power points, not least to avoid cables snaking all over the floor, and even if the room cannot be fully blacked out, it should be pretty dark when the lights are out. Heavy curtains, lined with blackout material, are ideal. If they are floor-length, you can use them as a background for portraits as well. If you use tungsten lighting, you may need forced ventilation in summer.

Flash

Snooted spot

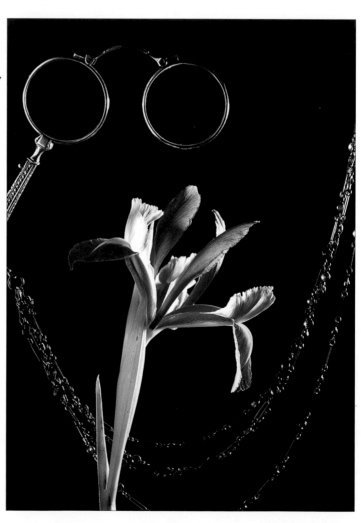

Iris and lorgnettes (RIGHT)
The real joy of a permanent studio is twofold. First, you have most of what you need, on hand, in one room. Second, you can set up the lighting plot, and come back to it when you next have time, inspiration, or have found the props you need to complete the picture.

Marie's studio (ABOVE)
If you do not need overhead lights, or if you only use them for small still lifes, then floor area is more important than ceiling height. Marie Muscat King sometimes uses her 200-year-old basement (now shored up with modern concrete!) as a studio. Exposure: 1 second at f/5.6 on ISO 400 film (Ilford XP2).

STORAGE, BITS AND PIECES

Once you have a permanent studio you accumulate all sorts of things that might come in handy. The range is vast: strong clips, modeling clay, wire, improvised and store-bought bounces, synch cables, flags, and so on. You need generous storage space to accommodate everything; many photographers hang the things they use regularly on nails or hooks for easy access, and also fill cupboards and drawers. In addition to storage space, you also need working space – surfaces on which you can rest cameras, lenses, and meters when they are not in use, without losing them in the melée of equipment which can soon coat every flat surface.

PART 2

PROJECTS

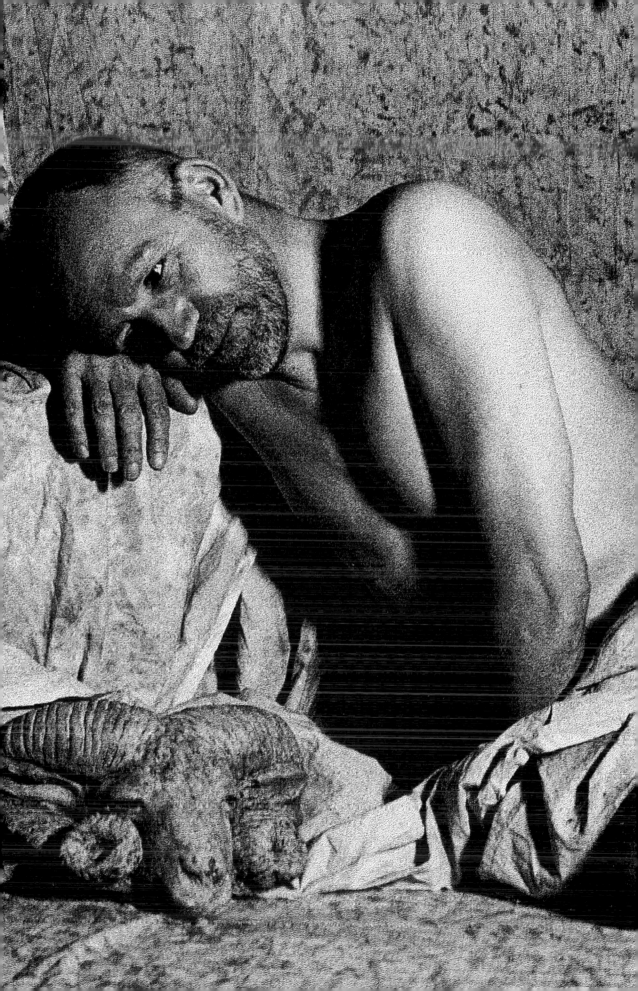

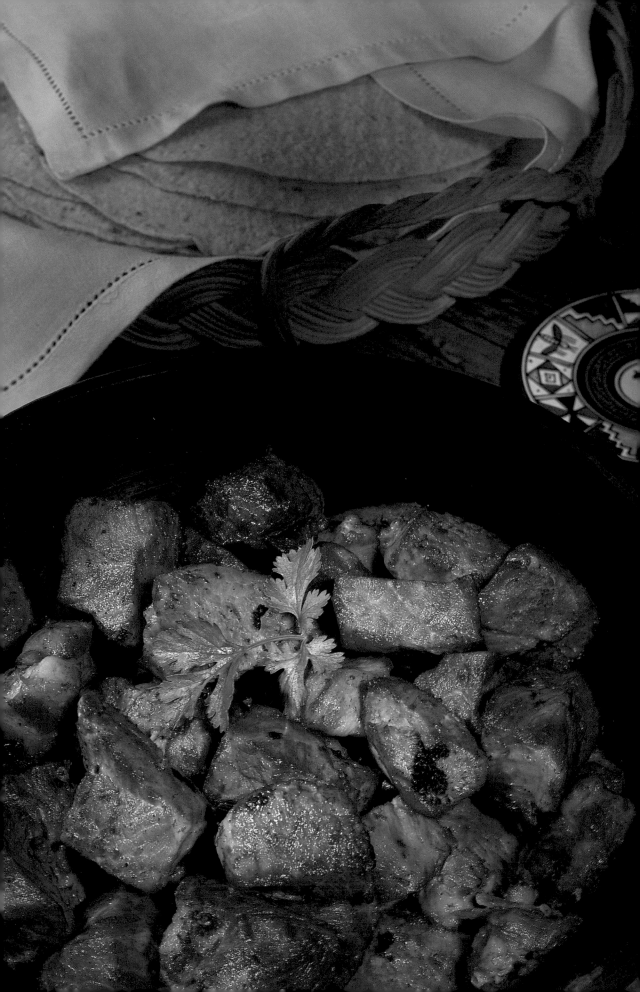

Still Lifes

PROJECTS

Shape and Shadow

PICASSO IS REPUTED to have said something like, "If you can handle three elements, use two; if you can handle seven, use five." Certainly, starting off simply is good advice in still lifes: a single light, a simple subject, a simple background, and black-and-white film. The only other thing you may need is a sheet of white cardboard as a bounce.

Choose something that you think is intrinsically beautiful, something with an attractive shape. At this stage, regard texture as a bonus; do not be seduced by something with an attractive texture but an awkward shape. Use an unobtrusive background with little or no variation in color and texture.

Black-and-white film removes the dimension of color and forces you to concentrate on masses of light and dark – the very skeleton of a composition. Using a single light means that you can study what happens when you move it up and down, nearer and further away, in front of or behind the subject. Move the subject and the camera, if necessary, as well as the light. Look through the viewfinder often, to see how the shapes come together in the viewfinder.

In essence, just play around. Try stopping down so that detail is obscured and all you can see is vague masses of tone; this is often the best way to stop looking at the subject, and start looking at the composition instead.

Seamless paper background

Black velvet background

RELATED IDEAS: SHADOW ALONE

Try concentrating on shadow alone. You need a hard light source – natural sunlight through a window is ideal – and a light background against which the shadow can show up. As children, we were all fascinated by the length of our shadows and how they both mimicked and distorted our every movement; as photographers, we can rediscover that fascination, for still lifes and portraits alike.

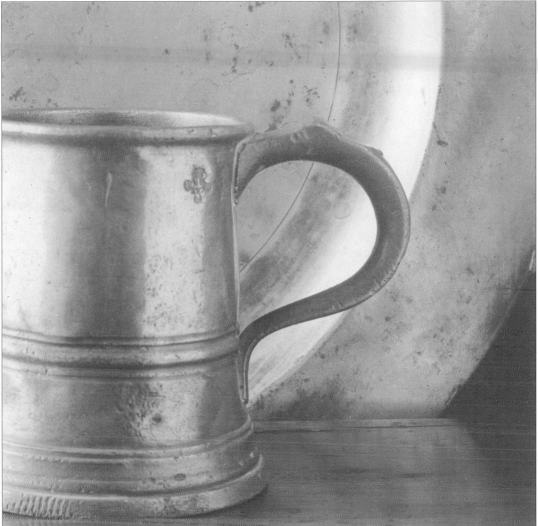

Close-up against black velvet background

Tankards (ABOVE and LEFT)

Props: Tankards 1870–1930; pewter charger (large plate), c 1780.

Background: Seamless paper (far left); black velvet (left and above).

Lighting: 200W domestic bulb in 40-cm (16 in) matte metal reflector; tracing paper diffuser; white polystyrene bounce. The lighting for all three pictures is identical.

Exposure: 10 seconds at f/16 on 4x5 in ISO 125 Ilford FP4 film, developed to high contrast in Paterson Universal developer.

Print: Contact print on printing-out paper toned in potassium chloroplatinite.

Problems and problem solving: After some excessively literal images of whole tankards, we found that pictures of parts of the tankards worked better, and a black background gave better contrast.

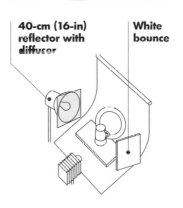

40-cm (16-in) reflector with diffuser

White bounce

FAILURES

Do not worry about failures. There are always subjects that you are convinced will work brilliantly – and that you simply cannot get to make a good picture. After a decent interval, anything from half an hour upwards, give up, and try something else. But keep your failed subject in mind, and try to visualize more carefully just how you see it and how you can make it work.

PROJECTS

A Classical Still Life

OR INSPIRATION IN classical still lifes, look at the works of painters through the centuries rather than at the works of photographers. From the invention of perspective onwards, countless artists took their inspiration from foodstuffs and kitchenware of all kinds; and you can do the same. Other still lifes – pieces of armor, flowers, and so forth – are less common because they often cost more and are less readily available than foodstuffs, and many would say they offer less variety as well.

The most effective still-life lighting continues to be a strong slanting key light with generous use of light and shadow (chiaroscuro). Our ancestors used a window or the sun, and you can do the same, or you can create similar effects with a focusing spot or a soft box. You can also recreate rich, painterly colors with slight underexposure

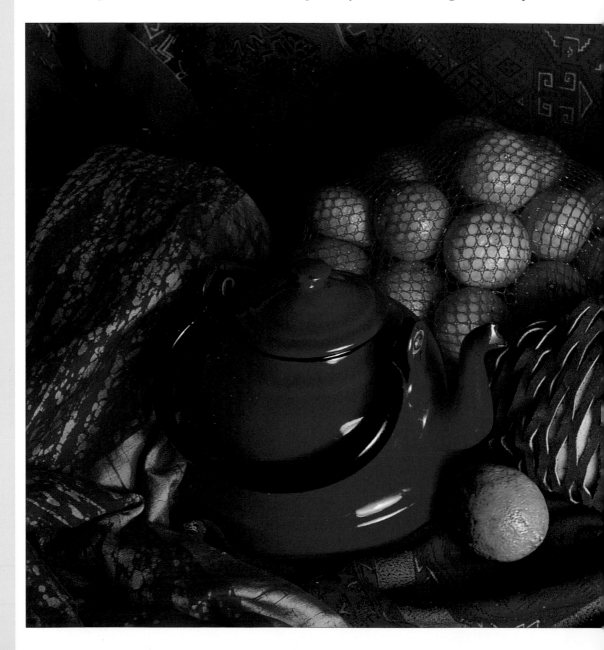

and with the use of high-saturation, slow films such as Fuji Velvia. With tungsten, long exposures are no problem; with flash, you may need quite a lot of power (or multiple "pops") in order to work at small enough apertures to get adequate depth of field.

Normally, texture is as important as form, so use a small aperture and (if possible) a larger format than 35mm. In 35mm, use the sharpest lenses you possess, and shoot at f/8 or f/11 – a small enough aperture to give you adequate depth of field, but not so small that resolution of the lens will decline below acceptable limits.

RELATED IDEAS: CHRISTMAS

The rich colors and textures of the still life with the kettle suggested the idea of newly-opened Christmas presents. The background and lighting are identical, but the subject matter is quite different – and so, surprisingly, is the mood. Once you have your camera set up, it is worth playing around with whatever ideas strike your fancy; you can learn a lot for the price of a single roll of film. It is also a good idea to experiment with both vertical (portrait) and horizontal (landscape) compositions.

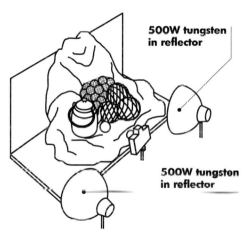

500W tungsten in reflector

500W tungsten in reflector

Fruit (LEFT)

Props: Fruit, kettle, leather bag.

Background: Home-made backdrop (see page 82).

Lighting: Two 500W tungsten lamps in 12 in (30 cm) reflectors: one camera left; the other camera right, closer.

Possible alternative lighting: Any reasonably hard tungsten sources, such as a desk lamp.

Exposure: 1/5 second at f/11 on ISO 50 film (Fuji Velvia).

Problems and problem solving: A longer lens than the 35mm used would have allowed a more distant viewpoint and more natural perspective. Bracketing was necessary to get the exposure right. To avoid "hot spots" (overbright areas resulting from the reflector design), use only the edge of the pool of light from each lamp, a technique known as "feathering."

PROJECTS

Flowers

THE SIMPLEST WAY to get good flower shots is in the field. Cover distracting backgrounds with a sheet of cardboard; some people carry several colors. An overcast day is often more effective than harsh sun; use an 81-series (warming) filter to counteract the blueness of the light.

In the studio, many of the best pictures delineate delicate textures and subtle gradations of color, concentrating on a single flower or a small group of flowers. Next in effectiveness and practicality come simple compositions of flowers in vases, against neutral backgrounds. Full-scale "painterly" still lifes are generally the most difficult, simply because it is so hard to assemble the right props and background.

Flash is all but essential – hot lights soon cause flowers to wilt – and because you are working close up, power is rarely a problem. If you use a plant mister to add "dew" keep the spray away from the lights to avoid the risk of short circuits, and do not overdo it so that water is dripping everywhere. Broad, soft lighting is usually the most successful, whether from front or back, though hard light and a dark background can also work well.

Against a light background, overexposure will often create a dreamy, ethereal effect – you may wish to combine it with soft focus to add to the unreality – while dark backgrounds allow you to underexpose and emphasize dramatic colors, textures, and shapes.

RELATED IDEAS: PRACTICE MAKES PERFECT

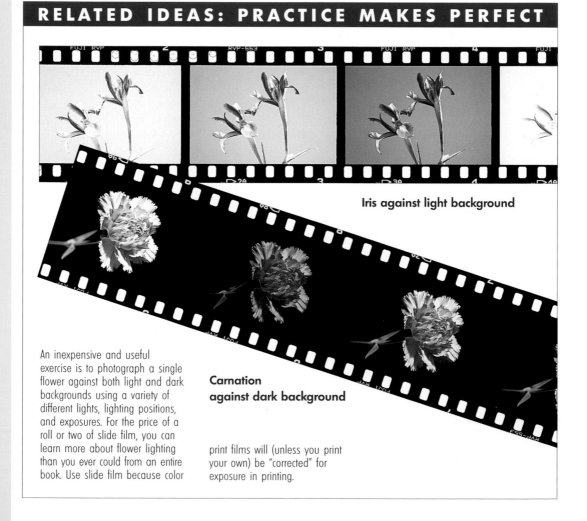

Iris against light background

**Carnation
against dark background**

An inexpensive and useful exercise is to photograph a single flower against both light and dark backgrounds using a variety of different lights, lighting positions, and exposures. For the price of a roll or two of slide film, you can learn more about flower lighting than you ever could from an entire book. Use slide film because color print films will (unless you print your own) be "corrected" for exposure in printing.

Monochrome flowers (ABOVE)
Flowers: Jasmine.

Background: Black art paper.

Lighting: Diffuse daylight from side and above (greenhouse).

Exposure: ¹/₁₅ second at f/16 on ISO 100 film (Ilford Delta) developed in ID-11.

Print: Ilford Multigrade 2.

Problems and problem solving: A frequent problem is movement of flowers in the breeze, but this was shot in a greenhouse. Slight underexposure will help darken white flowers, but you can do a lot in the darkroom by the careful choice of exposure and contrast grades.

Daylight through glass

THE BLUE FLOWER PROBLEM

Pale blue flowers are notoriously difficult to photograph, and often have a pinkish tinge which is irremovable with any normal filtration. This is a result of the sensitization of color films, and the only way to get around it is to choose a film which does not do it. Most modern films are pretty good, but if you have a problem, it is almost certainly the film, not you.

White on White

"WHITE ON WHITE," a situation in which a white subject gets lost against a white background, is a problem that any still-life photographer runs into sooner or later. Normally, you work around it, using a variety of tricks; producing a picture to illustrate it proved surprisingly difficult.

The tricks work in several ways. One is that the human eye accepts numerous tones of very light gray as "white," so it can differentiate several closely related tones. In color, too, there are "warm" and "cool" whites. Different textures reflect and even transmit light in different ways: the rough texture of an egg, the flat white of background paper, the glossy white of china. By astute use of light, plus black bounces as needed, you can exploit these differences in reflectivity and turn "whites" into very pale grays. Also, we see what we expect to see, and if you only lose a small part of the subject against the background, the eye will often fill in the missing edge.

Backlighting exploits differences in reflectivity, while sidelighting emphasizes texture; frontal lighting, on the other hand, invites trouble as it emphasizes neither. Lighting must be very even, or you will burn out highlights, but you may sometimes need to use small mirrors to help light a complex still life in order to differentiate the various planes of the subject.

RELATED IDEAS: BLACK ON BLACK

If you pour enough light onto a subject, there is no such thing as black, but only shades of gray. Much harsher lighting than for white on white is, however, normally desirable. Here we have a black enamel saucepan and black cast-iron frying pan on a black leaded cast iron-stove with a black stove-enameled chimney – and the background on the right is a wooden panel painted with blackboard paint. Bright reflections, especially at edges, can add still further to differentiation. The light was a single 800W focusing spot to camera left, about 26 in (65 cm) from the base of the chimney. Exposure: 1 second at f/16 on ISO 125 film (Ilford FP4).

CLOSE ONE EYE

You can see the roundness of an egg against a white background, so why can't you photograph it? Close one eye, and the answer will usually become clear. Our brains obtain a lot of information about depth from stereoscopic vision: close one eye, and the impression of depth vanishes. Conventional cameras have only one eye, of course, so "roundness" can be conveyed only by light and shadow.

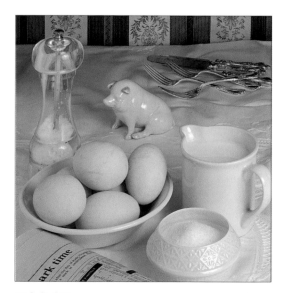

Sidelighting

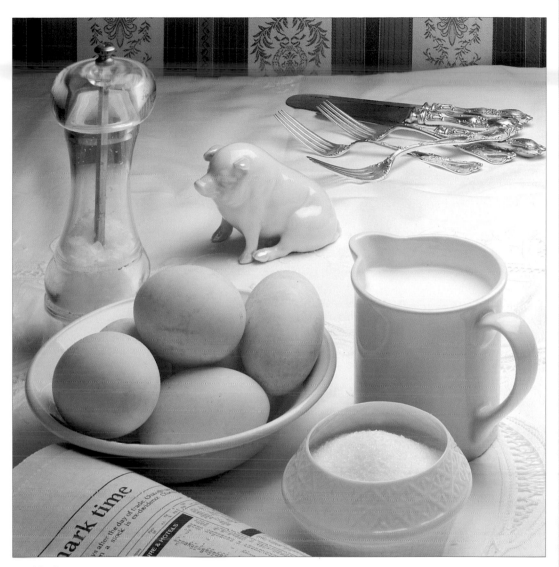

Backlighting

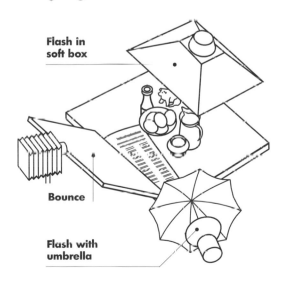

Flash in soft box

Bounce

Flash with umbrella

Bowl of eggs (ABOVE and LEFT)

Props: Duck eggs, white china, milk, sugar, silver cutlery, newspaper.

Background: Tablecloth, "curtains" from prop box.

Lighting: (Above) 1200 W-s flash in soft box above and slightly behind the subject.
(Left) 1200 W-s flash with umbrella to camera right; bounce in front of subject.

Possible alternative lighting: Any reasonably powerful sources, well diffused.

Exposure: f/32 on ISO 100 film (4x5in Fuji Astia).

Problems and problem solving: Fuji Astia is so good at holding subtle highlight textures that it made it difficult to demonstrate the problem – quite unlike the real world! But you can see how backlighting and overall evenness of lighting emphasize subtle differences in texture and reflectivity, while contrasty sidelighting reduces them. Precise exposure is critical: bracket with 1/2-stop or even 1/3-stop rests.

Shadowless Backgrounds

SHADOWLESS BACKGROUNDS ARE rarely required for pictorial purposes, but they are quite often called for in technical shots – and certain images, such as a single flower, can benefit from "floating in space." Even a large soft box, used close to the subject, will cast faint shadows. What you need to do, therefore, is to light the subject from below as well.

Ideally, you want a five-sided box which can be lit from any direction, but in practice you can usually get away with bounces (or diffused lights) at the back and sides. What you need, therefore, is a large soft light above and another large, soft light under 'a reasonably thick, rigid floor. Opal acrylic sheeting (Perspex or Lucite) is an ideal material.

You also need some acetate drafting film, which is like a very fine matte tracing paper. Tape this to the top of the rear wall of the box and the front of the floor, so that it forms a "sweep."

The third thing you need, though not for all shots, is white fabric to drape between the opening of the box and the lens of the camera. This removes reflections from the open side: see page 106, "Polished Surfaces."

You can use almost any sort of light; balance the intensity from above and below by turning a light up or down, or by moving one closer or further away.

RELATED IDEAS: TRANSLUCENT

With the right subject, lighting from below can be very successful. This image – a glass plate with grapes and flowers – shows the kind of thing you can do. A white bounce above the grapes adds some highlights and roundness to them, and a black bounce behind the grapes, just out of shot, is "picked up" by the far rim of the glass plate, which otherwise all but vanishes.

Shadowless background: Tools (RIGHT)
Props: Tools.

Background: Drafting film.

Lighting: One 1200 W-s flash unit above the subject, plus a Hancock's flicker-free light source (see page 49) under the subject; a layer of opal acrylic sheeting diffused the light from below. A red bounce added the hint of color in the ratchet handle. The smaller picture shows the effect without the lower light turned on: the shadows are faint, but clear.

Alternative lighting: Any broad, soft source will do, for above or below. It would even be possible to shoot with tungsten, provided you could diffuse the light enough and the heat from the lights did not melt the diffuser.

Exposure: $1/60$ second at f/16 on ISO 50 film (Fuji Velvia).

Problems and problem solving: Specks of dirt are a perennial problem with translucent backgrounds; remove them with tape, rather than trying to brush them off, or they may smear or scratch the background. Cleaning up the tools was very time-consuming, but fingerprints will show up mercilessly; so will grease inside the jaws of a spanner. The flicker-free unit gave a slight greenish cast on Velvia; weak magenta filtration (CC05M to CC10M) would be called for if color matching was essential.

Hancock's flicker-free and overhead flash

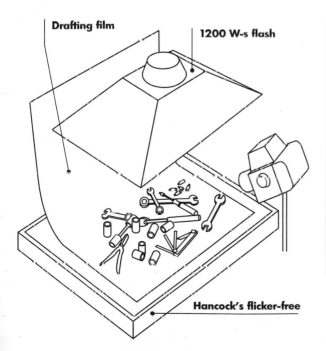

Drafting film

1200 W-s flash

Hancock's flicker-free

Overhead flash only

Dead Black Backgrounds

DEAD BLACK BACKGROUNDS are far easier to achieve than shadowless white backgrounds, especially in color, where anything that is 5 stops darker than a mid-tone will record as a featureless black. With the inherently greater recording range of monochrome, slight underexposure or the use of a harder-than-standard printing paper is sometimes required.

The traditional material for dead black backgrounds is black velvet, and for many purposes this remains the best. It is long-lived, and if the nap collapses it can often be revived by gentle brushing or by steaming. Although velvet can be a deader black than black flock, its texture is more easily seen, so

it is as well to have a choice of both. Specialist photographic backgrounds in black flock are available from a few sources, but a modestly priced alternative is self-adhesive flocked film, such as Fablon.

To keep the texture of the background to a minimum, it is advisable to use the softest light possible. Lighting from the camera position, or alternatively, perpendicular to the flock, generally gives the blackest effect. It is also a good idea to use a high-contrast, high-saturation color film – at the time of writing, Fuji Velvia was the leading contender – to help "lose" the background while still retaining the maximum possible color saturation in the subject.

Matte black background (LEFT)
Props: Buttons and brooches.

Background: Black flock.

Lighting: Single 1200 W-s flash unit, in soft box, above and slightly behind the subject.

Exposure: f/16 on ISO 50 film (Fuji Velvia)

Problems and problem solving: As with shadowless backgrounds, the surface mars easily. Velvet can be steamed to revive it but flock is not so forgiving. Pick up tiny pieces of dry debris with low-tack adhesive tape, such as masking tape. Reflections off the subject can be a problem; a polarizing filter can help.

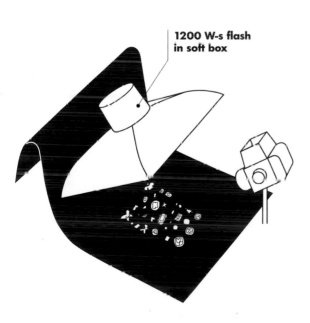

1200 W-s flash
in soft box

RELATED IDEAS: SHINY BLACK BACKGROUNDS

Use black acrylic sheeting (Perspex, Lucite) to create the blackest of all backgrounds. You need a dead black bounce behind it, as it will reflect everything (including the subject), but you can use very strong lights and it will not pick up reflections unless they are bounced straight into the lens. This potato masher was shot on slightly underexposed Fuji Velvia (using an exposure index of 80 rather than 50) for a very deep black while retaining detail in the stainless steel. Exposure: f/16 on ISO 50 film (Fuji Velvia).

Graded Grounds

GRADED GROUNDS, RANGING from light foreground to dark background or (much more rarely) from dark foreground to light background can be achieved in two ways: by using a ground that is itself graded, or by lighting a plain ground.

Graded grounds are available from a number of manufacturers or can be made by anyone sufficiently skilled with an airbrush. They are expensive to buy and mar easily, but if you want a dark foreground and a light background it is far easier to use a ready-made ground than try to light a plain ground – it is extremely difficult to get the right amount of light on the subject sitting on a dark foreground, while adding enough light at the back to make the background go light.

Lighting a graded ground from light front to dark rear is comparatively easy. Use a large, soft light source – a soft box is ideal – and interpose a sheet of plywood or something similar as a flag, as shown in the lighting diagram. Drape black velvet or other lightproof material to seal off any spill, which can otherwise ruin the shot.

Paint the underside of the wood with matte black paint (blackboard paint is ideal) to remove the risk of reflections. The gradation can be controlled by varying the height of the soft box and the flag.

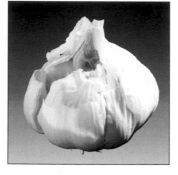

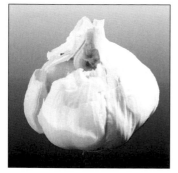

Garlic (ABOVE)
Computer-based image-manipulation programs such as Adobe Photoshop allow you to "drop in" graded grounds behind the subject to replace plain white (or black) backgrounds. The only difficult part is cutting out the subject convincingly, and this is a matter of practice and patience.

RELATED IDEAS: OTHER ROUTES TO GRADED GROUNDS

As well as making it much easier to grade "backwards" – from a dark background to a light foreground – ready-made graded grounds also allow you to add interest or texture to the background with flags or gobos (see page 58).

Grading with light (BELOW)

Props: Doris (Roger's 1950-vintage teddy bear) and Lambie-Pie (given to Frances in 1945).

Background: White seamless paper

Lighting: Single 1200 W-s flash unit, in soft box, above and slightly behind the subject.

Exposure: f/22 on ISO 100 film (Kodak Ektachrome 100HC).

Problems and problem solving: Light spill around the back and sides of the shading board is always a problem in shots like this. Butt the back of the board against the background (or rest it on top), and either use a board that is wider than the soft box, or curtain the sides as shown.

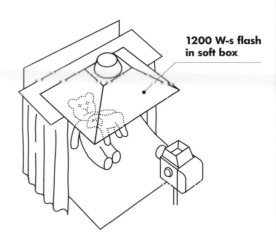

1200 W-s flash in soft box

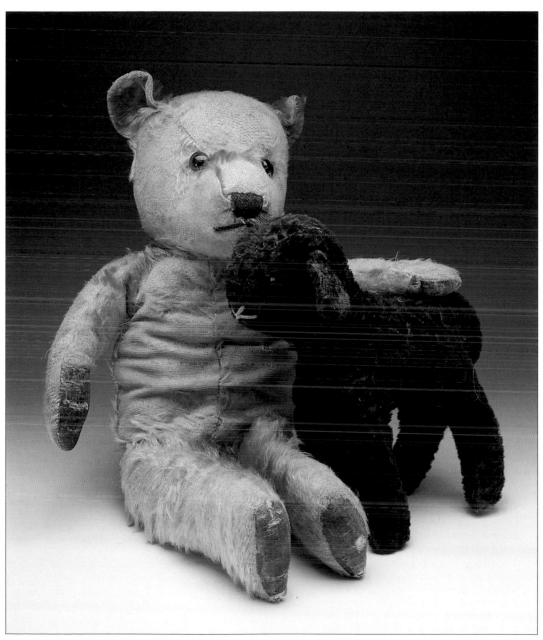

Polished Surfaces

THE ART OF lighting polished surfaces is summed up in a single sentence: Remember that you are not photographing the thing itself, but reflections in it.

As soon as you realize this, it becomes a great deal simpler to light anything bright and shiny. Use big, white bounces where you want highlights, and big, black bounces where you want shadows. There will still be times when you cannot get the effect that you want, but at least you will know where to make a start.

A "tent" of white fabric is useful, but remember to use a hood or funnel of white fabric between the "tent" and the camera.

Otherwise, the dark area of the studio around the camera (and the photographer, and anything bright in the studio) will be reflected in the polished surface.

Another possibility is to dull the surface of the subject. You can do this with dulling sprays (which can be hard to remove); by dabbing it with putty (which can be messy); or by leaving it in the refrigerator to let it chill, and then relying on condensation to dull the surface, though it is all too easy to overdo the latter and end up with rivulets down the sides, or to fail to notice that the condensation is slowly evaporating away as the subject warms up under the lights.

RELATED IDEAS:
FLEXIBLE MIRRORS

Mirrored acrylic sheeting can be used to create intriguing shots where the reflection is the most important part of the image;

modern fairground mirrors are made from this material, which is much cheaper and easier to work than glass. Mirrored and black

acrylic sheeting are available from specialist plastic merchants or sign-makers. Exposure: f/22 on ISO 100 film (Fuji Astia).

EXPOSURE AND DEVELOPMENT

Polished surfaces are normally shot as "high-key" subjects (see page 122), so it is often as well to cut exposure in monochrome, though there is rarely any need to curtail development: higher-than-average contrast often gives the best effect. Color shots are more difficult, but see "Related Ideas" on the opposite page.

Silver (LEFT)

Props: Silver tankard.

Background: Mirrored acrylic sheeting.

Lighting: Flash in soft box overhead, bounces on either side.

Exposure: f/16 on ISO 50 film (Fuji Velvia).

Problems and problem solving: This was a second attempt, using mirrored acrylic instead of the cheaper surface-silvered acrylic, which showed every flaw imaginable. In such a shot everything must be flawless and sparkling clean. White bounces surround the tankard for three-quarters of its circumference; a black bounce to camera left allows the hallmarks to read white on black. A sheet of black cardboard, with a hole cut for the lens, was needed to stop the camera (and the photographer) "reading" in the picture. Another black bounce, above the subject, reflects in the silvered acrylic as dead black.

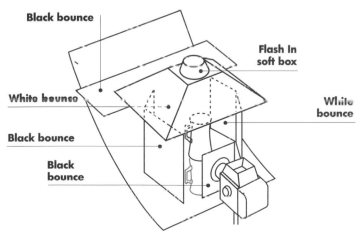

Black bounce

Flash in soft box

White bounce

White bounce

Black bounce

Black bounce

Glass

WHEN YOU LIGHT glass, you have to think about specular reflections and transmitted light as well as about shape and texture. The light will usually be reflected and refracted, and may be colored by both the glass and its contents. Backlighting alone can work well, but if texture is also important you normally need sidelighting as well. You sometimes need to cut a circle of black, white, or gray paper to go under a bottle or glass to avoid distracting refractions of the background or tablecloth.

Although you can light a scene with a candle alone, contrast is harsh and exposures tend to be very long. Use a supplementary light whenever possible, but do not overwhelm the candlelight with it; here, a desk lamp with a 60W bulb is effectively the key light, and lights most of the subject from the same direction as the candle. Placed to camera right and behind the subject, it makes the glass sparkle, and brings out the color of the whisky. The tungsten light is only partially corrected, to preserve overall warmth.

Nightcap (LEFT)

Props: Whisky bottle, cut-glass tumbler, book, candlestick, candle.

Background: Wooden table from junk shop, black fabric backdrop.

Lighting: 60W desk lamp, candle, white polystyrene bounce, piece of card as flag.

Exposure: 30 seconds at f/11 (to get depth of field) on ISO 100 daylight film (Fuji Astia) with Wratten 80A blue filter.

Problems and problem solving: Light shining through the bottle gave a green sparkle to the candlestick. A thin piece of black paper glued on the back of the bottle blocked the light.

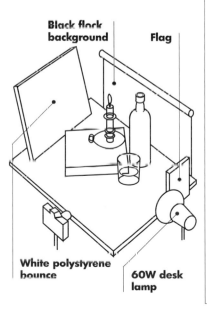

Black flock background Flag

White polystyrene bounce 60W desk lamp

RELATED IDEAS: RODCHENKO'S TOAST

Do not be afraid just to play with light and glass, and planes of focus. The original idea here was to contrast the clarity of the vodka with the rich color of the whisky in the other picture, using hard, directional light from a slide projector. But the way the glass spread the light was unexpected; and narrowing the beam from the projector emphasized the effect.

Suddenly, this somewhat "drunken" angle seemed precisely right. A mirror to camera right bounced some of the light from the projector back onto the bottle. The Russian photographer Alexandr Rodchenko (1891–1956) was noted for unusual tilted angles, which explains the title. Exposure: 1 second at f/32 on ISO 125 film (4 x 5 in Ilford FP4).

PROJECTS

Texture

PHOTOGRAPHY IS UNRIVALED for the representation of texture. A painter can suggest texture in many ways – but a photographer can represent almost any texture with remarkable precision. Large-format is the traditional approach but 35mm delivers excellent results. Use slow film; take particular care over focus and exposure; and shoot at the optimum aperture of your sharpest lens – around two stops below its maximum aperture. If you need to stop down further, remember that resolution deteriorates at small apertures.

Oblique lighting generally renders texture best, because of the way it casts shadows. Think of the way in which glancing sunlight illuminates a rough-textured wall or weathered wood. Direct frontal lighting (especially on-camera flash) is unlikely to be successful, because the tiny bumps and hollows that make up texture are all equally (and flatly) lit.

Many subjects lose their texture under prolonged lighting. Hot lights make flowers wilt, ice cream melt, food go dry, and faces sweat – even under flash the fresh-cut surface of a tomato will be very different after five minutes. You have to work fast and, preferably, with one or more changes of subject, keeping the freshest for the final shot.

RELATED IDEAS: SKIN TEXTURE

Portraits shot as extreme close-ups reveal pores and flaws and are not for the vain; but the impact can be considerable. If the subject has a flawless skin, of course, the impact is all the greater. Many other subjects also bear very close examination: feathers, anything battered or worn, man-made materials with repetitive textures. Exposure: f/11 on ISO 100 film (Ilford Delta).

Capturing texture (BELOW)

Props: Tibetan Buddhist rosary, shells, driftwood.

Background: Home-made from hand-dyed fabric.

Lighting: Electronic flash head, 1200 W-s, with honeycomb.

Possible alternatives: Reasonably hard tungsten light, such as a desk lamp, or even a small portable flash, though without a modeling light you will just have to visualize the effect.

Exposure: f/16 on ISO 100 film (Fuji Astia)

Problems and problem solving: This is the second attempt. The initial exposure overemphasized the rather harsh texture of a synthetic-fabric backdrop, and the transition from light to dark behind the wood was too abrupt. The second exposure was therefore made on a background of natural cotton. Slight back-lighting emphasizes the reflectivity of the shiny surfaces (beads, shells) and the grazing light throws the texture of the driftwood into sharp relief.

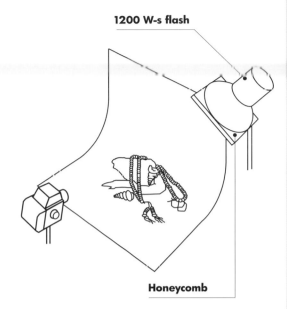

1200 W-s flash

Honeycomb

Telling a Story

ANARRATIVE STILL LIFE does more than just hint at a story behind the props; it almost tells it out loud. Narrative still lifes are often inspired by something you find, or something you have had lying around for ages. There are two challenges in creating them: first, assembling them, and second, lighting them.

This is a book about lighting, so the main thing that needs to be said about assembling a narrative still life is that as long as something looks more or less right, few people will worry about the exact details. It is also worth adding that while it is all too easy for a richly narrative picture to be too sparse, it can also be too busy. Take out anything that is not essential.

As for lighting, you could do worse than to think how your favorite movie directors might handle it. Overexposed, with soft colors, for a science-fiction look? Rich and dark, with marked shadows, for film noir? Harsh monochrome for a documentary feel? You can often conceal shortcomings in unimportant parts of the picture through careful use of shadows, but important parts of the story must be big enough to see and lit up well enough to stand out.

RELATED IDEAS: UNLUCKY PFENNIG

Perhaps it is the influence of films such as the Indiana Jones series, but the 1930s seem particularly rich in evocative imagery; and the 1940s of course had the war. "Unlucky pfennig" was inspired by a wartime map and a 1941 German pfennig, which was lightly oiled to make it stand out in the picture. The (single) light was intended to be cold and bleak: a small (24-inch, 60-cm) square soft box that slightly backlights the subject to catch highlights on the camera, the coins, and the gun. You could achieve a similar effect with any large, diffused source. Exposure: f/32 on ISO 100 film (Fuji Provia).

Freelance Dreams, 1936 (RIGHT)

Props: Numerous, as seen, including a copy of the 1936 Writers' and Artists' Yearbook.

Background: Wooden table from junk shop, map of Himalayas hung on sheet of plywood.

Lighting: 1200 W-s flash in soft box overhead, 800W tungsten focusing spot to camera left. Duplicating this with improvised lighting would be difficult.

Exposure: 1 second at f/22$^{1}/_{2}$ on ISO 100 daylight film (Fuji Provia).

Problems and problem solving: The uncorrected tungsten light gives the impression of sunset, but without the flash fill, the whole picture is unpleasantly yellow and very contrasty. The flying jacket was poorly differentiated from the map; a 35mm film canister behind the lapel pushes it forward and improves the separation. A small mirror throws some light on the lens of the Graflex, which otherwise was a black hole.

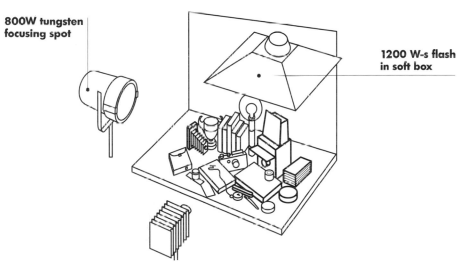

800W tungsten focusing spot

1200 W-s flash in soft box

Food

FOOD PHOTOGRAPHY IS clearly related to classic still lifes, but it is also significantly different. You have to work very quickly, because there is nothing so unappetizing as a picture of congealed, dried-out food, so plan every detail beforehand. In addition, you also have to strike a balance between a naturalistic setting and one that is so detailed and overcrowded as to overwhelm the food.

Although tungsten light gives a wonderfully warm, welcoming effect, the only convenient way to use it is in a powerful focusing spot at a good distance from the food; otherwise it will dry it out, without keeping it warm. A useful (and common) trick is to mix flash and tungsten for "skylight" and "sunlight." You can use an amber gel to warm up a spot with a snoot (see page 62) but it is rarely as sun-like as tungsten.

Use empty plates and crumpled paper to "block in" the rough composition of a shot, then make two sets of the dish: one for the set-up, and one for the final shot. Surprisingly often, you will get the shot you want with the first set, but if you do not have more food available, you will sooner or later wish that you did.

Appetizers (RIGHT)

Props: Numerous, as seen. This was shot as the cover for a book on "little foods" from all over the world.

Background: Wooden table made from reclaimed timbers; shot from directly overhead.

Lighting: 1200 W-s flash in soft box beside camera, 800W tungsten focusing spot at 10 o'clock. Duplicating this with improvised lighting would be difficult.

Exposure: $^1/_2$ second at f/16 on ISO 100 daylight film (Kodak EPN).

Problems and problem solving: It is virtually impossible to take this sort of shot single-handed. Professionals normally work with (at the least) a cook and a food stylist as well as one or more assistants. Two determined people can, however, do it. The table top was removed and laid on the floor to give a convenient working height; black velvet was spread under the corner to conceal the studio floor.

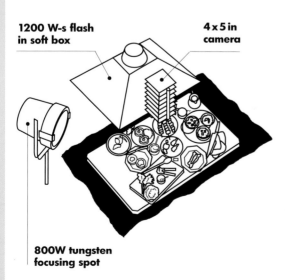

1200 W-s flash in soft box

4 x 5 in camera

800W tungsten focusing spot

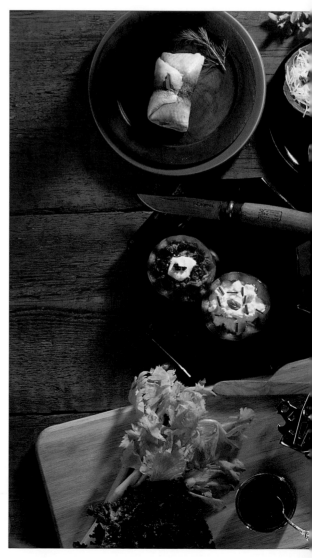

RELATED IDEAS: HOT AND COLD FOOD

Start with cold food, which does not dry out too quickly – like the smoked salmon pictured right. The legendary tricks of using glycerine to make food shine and cigarette smoke for steam are much rarer than they used to be: look at old cookbooks and the food is a lot less edible-looking. With hot food, making two (or more) batches is usually essential: carnitas (far right) have a life of about four minutes before they begin to dry out. Also, replace any sauces or garnishes as well as the main subject before you take the final shot.

PROJECTS

Double Exposures

THE CAMERA CAN give us X-ray vision, create ghosts, and superimpose one thing onto another quite casually. "Ghost" exposures are most easily achieved by making two exposures of the same subject, without moving the camera, while adding or subtracting one thing from the field of view. Both the exposures must be half the metered exposure, or the result will be overexposed.

A more sophisticated version of the same technique is almost like a mat, where one thing is exposed on one part of the film and another thing is exposed on another part. The first exposure shows the whole subject, normally lit, while the second uses black velvet or black flock to mask off everything except the part you want to see "through": the open lid of a box, for example. By varying the relative exposures, the "ghost" can be made more or less substantial. As with the other type of "ghost," lighting is generally easiest to control if it is fairly soft, and direction must be the same in both exposures if the effect is to look convincing.

As most photographers learn to their cost, sooner or later, it is all too easy to record one image on top of another inadvertently. Usually, the effect is a disaster, but just occasionally it can be a success; and if you can keep one picture in your mind's eye, while you deliberately superimpose another on it, you can create striking and memorable images.

An open and shut case (RIGHT)
Props: Briefcase and camera equipment.

Background: Wooden table; black backdrop.

Lighting: Hancock's flicker-free light source (see page 49). Alternatively, a soft box or diffuse daylight.

Exposure: 2 x 1 second at f/16 on ISO 100 daylight film (Fuji Reala).

Problems and problem solving: Exposure determination was quite difficult and involved a certain amount of trial and error with Polaroids. The final shot was taken with two identical, full exposures at the metered reading (the lighting set-up was identical for both shots). Another problem was wrinkles in the black velvet; the highlights read too bright. This was solved by cutting pieces off a roll of black flock background (from Colorama) and butting them against one another, rather than trying to drape velvet. Cutting up velvet would have worked as well. The pictures had to be cropped slightly to conceal the fact that the masking was inadequate at the top: the upper part of the briefcase was double exposed, and the colors were degraded and flat.

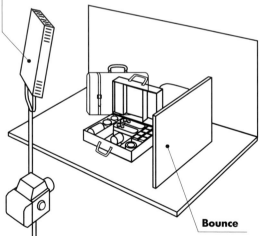

Hancock's flicker-free

Bounce

KEEPING ALL IN PLACE

A major problem with double exposures can be subject movement or camera movement between exposures. You need the most substantial tripod you can muster, and you have to use a very delicate touch when adjusting the subject. It is generally a good idea to make two or three identical (or substantially identical) double exposures, in case you inadvertently move the camera or the wrong part of the subject in one of them.

Open case with no double exposure

Exposure 1 – Interior
Cover all exposed parts of the exterior in black flock. Shoot using the full metered reading.

Exposure 2 – Exterior
Remove the flock and shut the case. Expose the same frame, again using the full metered reading.

The final result

Portraits and Nudes

Head and Shoulders

High-key Portraits

Low-key Portraits

Informal Portraits

Formal Portraits

Portrait of a Child

Parent and Child

Group Portraits

Pets

The Gentle Nude

The Dramatic Nude

Head and Shoulders

HEAD-AND-SHOULDERS portraits and "large heads" can reveal character wonderfully, and have the advantage that they do not require a huge studio. Long lenses give pleasing perspective and allow backgrounds to be thrown out of focus; backgrounds should in most cases be far enough from the subject to be lit independently.

Depth of field for such portraits is traditionally limited, with only the eyes necessarily in sharp focus, so you do not need very much light. Nowadays, however, many photographers prefer to have greater depth of field.

Experimentation will soon show why it is generally best to have the key light fairly close to the camera, rarely more than 45 degrees from the camera/subject line, and above the subject's eye-line. The shadows to watch are those from the eye sockets and the nose. Also, watch out for excessive reflection from the forehead – even with men, a dab of translucent powder may be desirable.

A key light alone gives the most dramatic effect; the more fill you use, the softer and more flattering the overall effect will be. Effects lights are sometimes used to increase the differentiation of the hair from the background, which may be lit with spill from the main lights, or left to go dark, or lit separately, especially for high-key portraits (page 122).

Plaster heads (BELOW)

A useful exercise is to borrow a plaster mannequin and to try a full range of lighting. Here, a single flash is moved progressively to the right.

Monsieur Muscat (RIGHT)

Background: Home-made (page 80).

Lighting: Two 250 W-s flash heads, the key in a bounce umbrella, the fill in a shoot-through umbrella.

Exposure: f/5.6 on ISO 400 film rated at EI 320 (Ilford HP5 Plus).

Problems and problem solving: Although normally never used for portraiture, the only lens available was a 35mm f/2. The disadvantages of the 35mm were overcome by choosing a low viewpoint, emphasizing the model's massive frame.

250 W-s key flash in bounce umbrella **250 W-s fill flash in shoot-through umbrella**

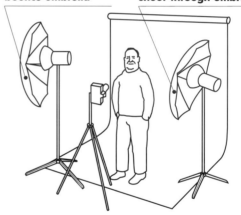

NOSES

As a general rule, the tip of the nose in a three-quarter profile should either break the cheek line decisively, or be well clear of it; if it is level with the cheek-line, it often looks awkward. Profile shots are best avoided for those with large noses, and lights should be neither too high nor too much to the side lest they cast unduly large shadows.

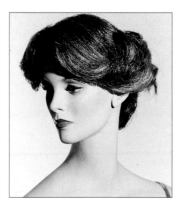

Flash three-quarters right

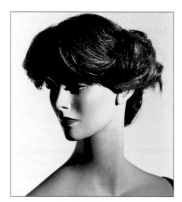

Flash full right

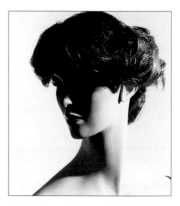

Flash three-quarters behind

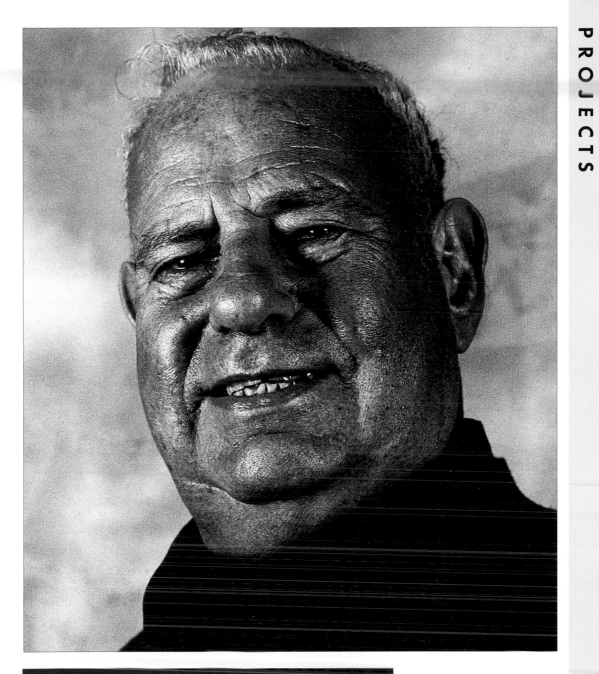

RELATED IDEAS:
PASSPORT PICTURES

Regardless of Fuchs's Warning ("If you look like
the picture in your passport, you are not well
enough to travel"), it can be worth exposing a
roll of film to get a good passport portrait.
Black-and-white passport pictures are still
acceptable in most countries and can make a
much more attractive portrait than something
knocked off in five minutes in a photo booth.
Check the passport form for pose and size
requirements before shooting, though.
Exposure: f/8 on ISO 125 film (Ilford FP4).

High-key Portraits

HIGH-KEY PORTRAITS are traditionally associated with children and young women, especially blonde young women, but the technique can be used over a surprisingly wide range of subjects.

There are two key points to remember. The first is that high key is not the same thing as low contrast. The best high-key pictures are often surprisingly contrasty, but the light tones predominate. The second is that backgrounds for high-key portraits almost invariably have to be lit separately, and generously; white backgrounds are the norm. This can place quite considerable demands on a modest lighting set-up. A useful trick is to hang a plain white backdrop in front of a window, so that the light diffuses through it. Put it far enough out of focus to "lose" any texture or detail, and watch out for shadows from window uprights.

The lighting on the subject is normally very soft and diffuse, though it is possible to shoot high key with a hard key light provided you use a generous fill and a tight lighting ratio – 2:1 is about as far as you dare go. Big reflectors on all sides – even on the floor – will make it much easier to get a satisfactory result.

EXPOSURE AND DEVELOPMENT

In monochrome, give minimal exposure and generous development to ensure maximum differentiation in the light tones. In color, the overall effect of any high-key picture is likely to be rather "washed out," which is why the effect is likely to be more successful with blondes than with brunettes.

RELATED IDEAS: OTHER HIGH-KEY SUBJECTS

High-key lighting is not necessarily restricted to portraiture. In flower photography, it can be taken to extremes, as it has also been here; but it can also be used in many other still lifes of pale-colored subjects. Cosmetics are often photographed this way for advertisements, especially for hypo-allergenic cosmetics or those where "purity" is being stressed.

High-key portrait (RIGHT)
Model: Rebecca.

Background: White seamless paper.

Lighting: Two standard flash heads on background. Large bounce on the floor, just in front of subject.

Exposure: f/11 on ISO 125 film (Ilford FP4 Plus).

Problems and problem solving: High key is a conflict between getting the light absolutely even and introducing enough variation in the light to create modeling. The unusual approach of a big, soft key and a more directional (though, of course, weaker) hard fill created a remarkably successful overall effect.

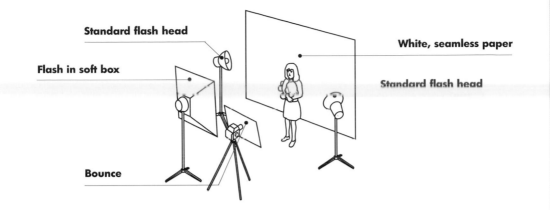

Standard flash head

Flash in soft box

White, seamless paper

Standard flash head

Bounce

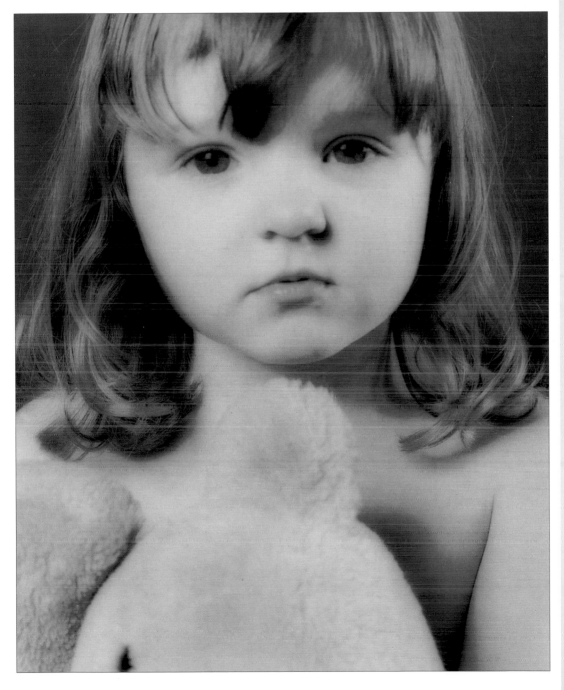

PROJECTS

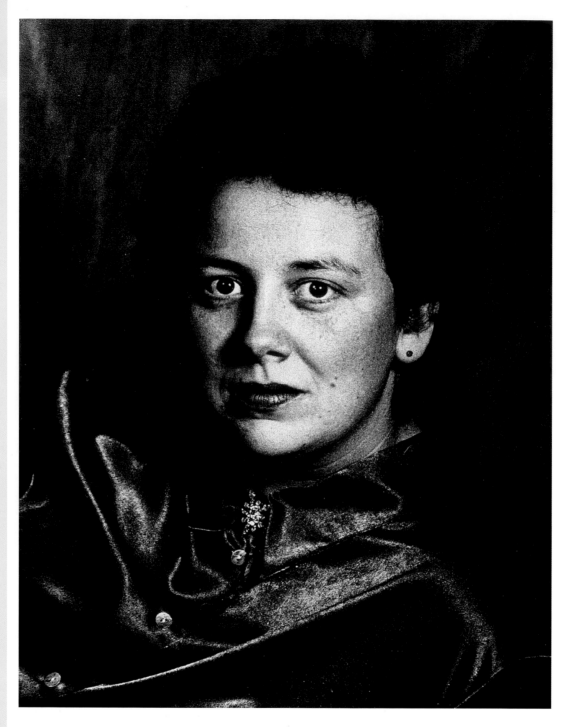

EXPOSURE AND DEVELOPMENT

Both exposure and development are far more critical for low-key images than they are for high-key. Expose generously, typically about 1 stop more than is indicated by most incident light meters (in-camera meters will automatically recommend extra exposure), and do not overdevelop or the important highlight areas will "block up." Do not, however, underdevelop or there will be inadequate differentiation in the shadow tones and the print will be flat and muddy.

Low-key Portraits

LOW-KEY PORTRAITS ARE composed principally of dark tones and are normally associated with mysterious, romantic moods, or with reflection or even depression. Although middle-aged faces with plenty of character lines are easiest, low-key pictures are also popular with many young subjects, as they reflect (the sitters feel) the passion and tragedy of their existence. Adults may not always see the relevance, and may see the portraits as formulaic and empty, but the sitters frequently love them. This is true even when they are manifestly unsuitable subjects, such as young blondes.

As with high-key portraits, contrast should not be restricted: the picture will look better if there are some highlights. These may be limited to the highlights in the eyes, but a small area of light somewhere in the picture normally emphasizes the overall dark tone rather than diminishes it. The main tones should, however, be inherently dark: dark clothes, dark backgrounds, and (preferably) swarthy skins and dark hair. A hat may be useful with balding male subjects, or a dark shawl for fair-haired women.

Unlike high key, which can to some extent be emulated from any negative via underexposure and a soft paper grade, low key depends very much on the right choice of subject and the right lighting to begin with.

Low-key portrait (LEFT)
Background: Home-made backdrop (see page 82).

Lighting: Two 500W tungsten lamps in 8-in (20 cm) reflectors. Key light is to camera right, somewhat above model's eye-line; fill (to pick up jewelry and highlights on blouse) is to camera left, higher and further away.

Possible alternative lighting: It would be possible to light this shot with powerful domestic lamps, but a very long exposure would be needed.

Exposure: 1/30 second at f/4 on ISO 200 film (Paterson Acupan).

Problems and problem solving: The negative was rather thin − generous exposure is a good idea with low-key pictures, where by definition there is a good deal of shadow detail − and it had to be printed on correspondingly hard paper.

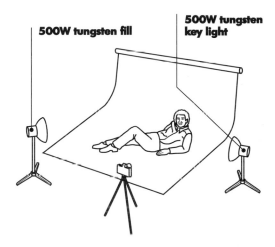

500W tungsten fill

500W tungsten key light

RELATED IDEAS: MOOD

Low key is not just a technique for conventional portraits, as this unusual study by Marie Muscat King shows. The model is wrapped in muslin, and has adopted a wide range of poses; this one, with the gaunt shoulder blades and the hands seemingly protecting the neck, is redolent of despair − a mood that is accentuated by the gloomy, low-key image. In fact, the model was laughing seconds later. The sole light is a tungsten lamp in a 12-in (30-cm) reflector, high and to camera right. Exposure: 1/15 second at f/8 on ISO 400 film (Ilford HP5 Plus).

PROJECTS

Informal Portraits

THE DIVIDING LINE between a formal portrait and an informal portrait can be very uncertain, but the main differences are that the subject of an informal portrait is normally dressed more casually, and that the background or surroundings relate to a hobby or interest rather than to a career.

This can be very important from a lighting point of view. A man seated at a piano could equally well be the subject for a formal portrait or for an informal portrait; but in the former case he would probably be dressed in tails, as for a concert, and the lighting would focus very much upon him, while in the latter he would be dressed informally and the portrait would normally show more of the surroundings.

For this sort of informal portrait, you generally need to light quite a large area (in order to show the surroundings) and the lighting needs to be fairly soft and even; the subject is shown in relation to his or her surroundings, not in isolation. Quite heavy "gardening" may be necessary to remove clutter from the background, though the lighting can be directed (with grids, spots, snoots, or flags) to make sure that unimportant areas are not too brightly illuminated.

RELATED IDEAS: PROPS

Instead of concentrating on the subject in his or her surroundings, use a single, characteristic prop to sketch the subject's character or interests: a camera for a photographer, a pipe for a pipe-smoker, a favorite piece of jewelry for someone noted for their elegance, and so forth. In this case, the technique is much as for a head and shoulders portrait (see page 120). Roger has been using Leicas for over 25 years; this was shot to accompany an article for the Leica Historical Society of the United Kingdom. Exposure: f/11 on ISO 200 film (Paterson Acupan).

Amanda (RIGHT)
Setting: Sitting room.

Lighting: On-camera flash, bounced off the ceiling.

Exposure: 1/30 second at f/8 on ISO 400 film rated at EI 320 (Kodak Gold).

Problems and problem solving: Small nieces move fast – so fast film and flash are needed to "freeze" movement. Bounced flash avoids red-eye, though you need a fairly powerful unit (this was a Metz 45 CT-1). Rating the film 1/3 stop slow gave additional latitude for underexposure. Backgrounds are not controllable and you have to shoot for the percentages: you will be lucky if a third of the shots are usable.

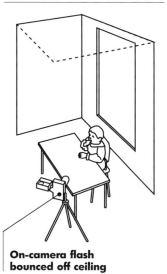

On-camera flash bounced off ceiling

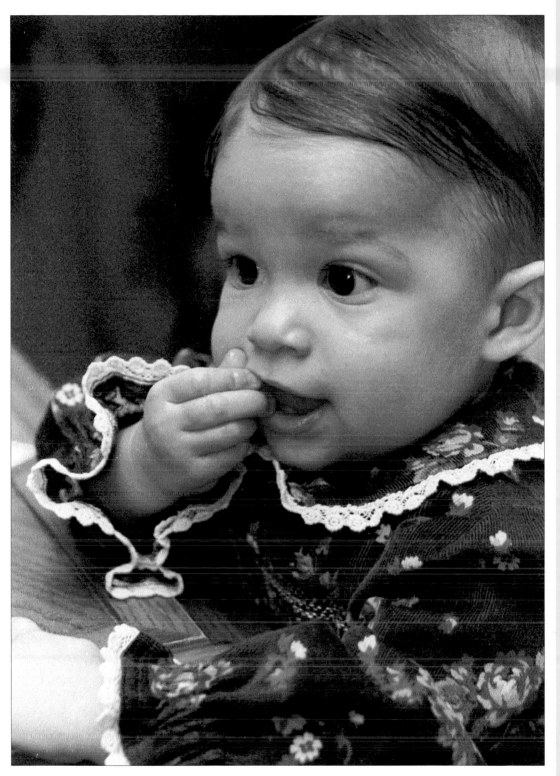

PROJECTS

Formal Portraits

THE PRINCIPAL DIFFERENCE between a formal and informal portrait is that the formal one is a matter of record, a lasting statement of what a person looks like – or perhaps more importantly, of what they wish to look like. The second major difference is that a formal portrait is normally lit with some care; spontaneity is not the usual goal.

Arguably the finest formal portraits of all time were made in the 19th century; the Victorians liked full-length portraits against big, painted backdrops, so vast daylight studios were the rule, with north-facing windows, skylights, ceilings 20 feet (6 meters) high, and 40 feet (12 meters) from wall to wall in length. The ethereal quality of huge, soft light sources is hard to match. Today, most people are hard-pressed to fit a three-quarter pose into one of the larger rooms of the house; half-length and (better still) head-and-shoulders poses are a good deal more feasible.

An extremely useful tool for portraiture is the Tri-Flector, a three-paneled reflector placed in front of the subject to reflect light back up onto the face; the angle of the two "wings" on either side of the main panel can be adjusted so that, when used with a large, soft light source, the illusion of being wrapped in light, which was so common in Victorian pictures, is recreated to some extent.

RELATED IDEAS: PEOPLE AND THEIR SURROUNDINGS

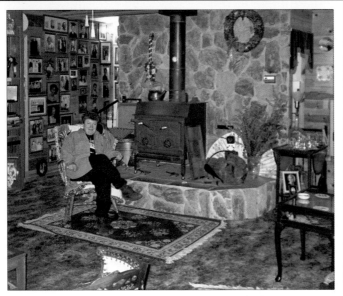

Sometimes, you can say more about a person by including his or her surroundings than you can by shooting a more conventional portrait. An obsessive collector, for example, could be surrounded by his or her collection. This is the parlor of a bed and breakfast in California's Gold Country. Always keep an eye open for locations that can be useful for portraits, and that match a particular person's personality or self-image (or would-be self-image). Here, the lighting is surprisingly simple: some room lights were turned on, and others off, to create the right balance, while a small on-camera flash completed the lighting plot. Exposure: 1/30 second at f/5.6 on ISO 400 film (Kodak Gold).

Portrait (RIGHT)
Subject: Mandy Barber.

Background: Home-made backdrop (see page 82), left to go dark.

Lighting: 1200 W-s flash in large (36 x 48 inch/90 x 120 cm) soft box overhead, plus Lastolite Tri-Flector; separate hair light.

Exposure: f/11 on ISO 100 film rated at EI 80 (Fuji Reala).

Problems and problem solving: Mandy's best features are her hair and her eyes, so the portrait concentrated on these. The hair light was as powerful as we dared – any more would have burned out to a bright but essentially colorless fringe. The bounce threw plenty of light back into her eyes but carried the penalty of a triple highlight. Another version, with a separately lit background, was rejected because it did not give adequate differentiation in the hair.

PROJECTS

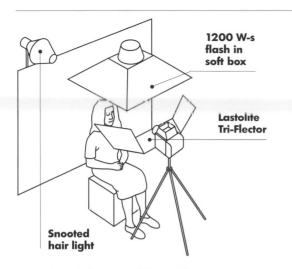

1200 W-s flash in soft box

Lastolite Tri-Flector

Snooted hair light

THE BUSINESS PORTRAIT

Business portraits are a special category of formal portrait, where the principal skills lie not in the lighting but in dealing with the sitter and timing the session. Often, the subject of the portrait will be unable to allocate a reasonable amount of time for the portrait, so you need to divide your session into three parts, most of which will be spent without the subject present. First, scout out a good location. Second, set up your lighting and make a Polaroid test if possible using a stand-in. Third, invite the portrait's subject to have his or her photograph taken.

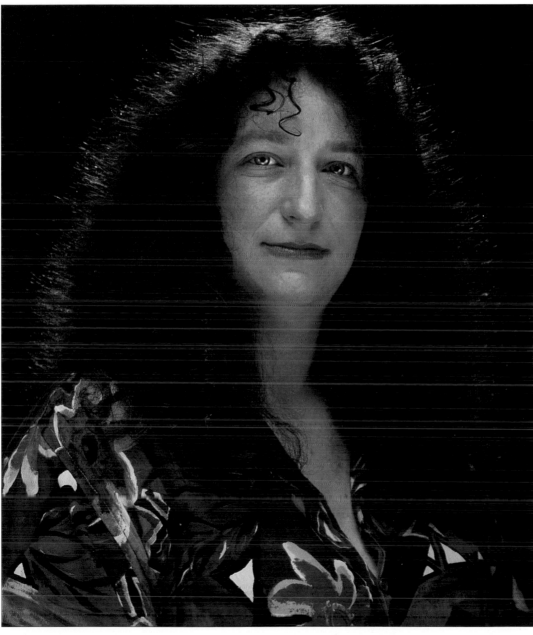

PROJECTS

Portrait of a Child

A BIG, SOFT KEY light is always flattering; soft lights are pretty much the standard for children and for traditional portraits or women, and Lastolite's Tri-Flector softens the light still more. Hairlights are a matter of fashion and of taste, but they work very well with most girls and young women – the younger the subject is, the more dramatic you can afford to make the hair light.

Set the lights up before your subject arrives so that when the child does arrive you can pay attention to him or her, not your equipment, and remember that it is almost impossible to get a good picture if the child becomes bored. Don't insist on smiles all the time; adults cannot always smile to order, so why should a child be expected to do so?

Serenity (RIGHT)
Don't always attempt to show a happy child – a sad or reflective image can be far more poignant.

RELATED IDEAS: VARIATIONS ON A THEME

Try to get the model involved in the shoot: allow her to create her own pictures as well as yours, and try for variety. All the pictures on this spread were shot in a single session, but the results are very different. The picture opposite would appeal to a grandparent – all innocence and light. The strongly sidelit picture to the right looks like something from an advertising campaign on runaways (most children love acting, and can do it almost effortlessly); and the picture above right is a tell-it-like-it-is shot of a girl a few days before her 13th birthday, using substantially the same lighting as the main portrait. With younger children, be generous with props: think of a little boy "shaving" (with no blade in the razor) or a little girl let loose on a make-up box.

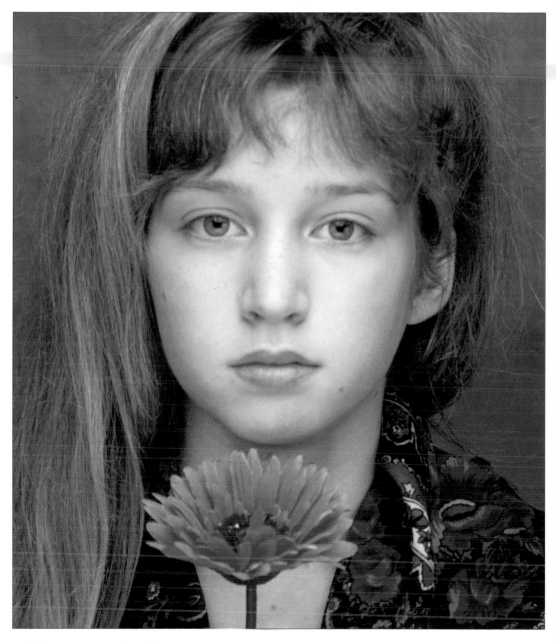

Sophie Muscat King (ABOVE)

Props: Sophie's own clothes.

Background: Home-made backdrop (see page 82).

Lighting: 1200 W-s flash with soft box; Lastolite Tri-Flector.

Exposure: f/11 on ISO 100 film (Fuji Astia).

Problems and problem solving: The Tri-Flector is what its name suggests, a three-winged reflector. Finding a stand that would hold it low enough was a problem, solved with a high draftsman's stool and a stand made by sawing up a rusty old projector screen stand that we had been given. The camera was used at or below eye-level to add dignity: all too often, children are photographed from above. With older children, where complexions can be a problem, use appropriate make-up or shoot in black and white (much more flattering to teenage spots).

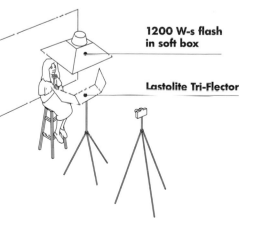

1200 W-s flash in soft box

Lastolite Tri-Flector

PROJECTS

Parent and Child

PHOTOGRAPHING A PARENT and child together is very much like photographing any other pair of people – except that there is an even more special bond than there is between two lovers, or husband and wife, or whatever.

Because you are photographing two people, you are unlikely to suit the lighting perfectly to both of them. Sometimes, particularly with a mother and small child, soft, high-key lighting will work very well; and with a father and son, you may be able to use "character" lighting (plenty of chiaroscuro,

fairly hard and directional). In general, though, you need a compromise; typically, a broad, soft but directional key light, with a big bounce or a secondary light for the person further from the main light.

The enduring nature of the bond means that you can often afford to be more fluid and relaxed than you are when you photograph two friends or even lovers; you can find a pose in which both parent and child are comfortable, and you can expect them to hold it (or something like it) for quite a while.

**RELATED IDEAS:
NATURALLY LIT PORTRAITS**

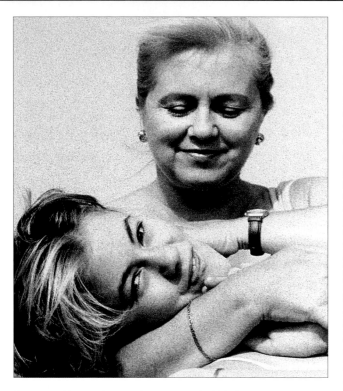

Try out your ideas under natural light. You may not have the control available in the studio, but you can shoot quickly and freely in less oppressive surroundings than a studio. Later, apply the lessons you have learned using controlled light. Julie and Holly were photographed under high, hazy summer sun (normally the worst of light) but the immediacy of Holly's gaze and her mother's focus on her are exemplary illustrations of the parent/child relationship.
Exposure: $^1/_{250}$ second at f/8 on ISO 200 film (Paterson Acupan).

**Mother and daughter (RIGHT)
Subjects:** Karen and Rachel.

Background: Home-made backdrop (see page 82).

Lighting: Two 250 W-s flashes, one with a silver bounce umbrella as key, the other with a shoot-through umbrella as fill.

Exposure: f/5.6 on ISO 125 film (Ilford FP4).

Problems and problem solving: Rachel was at the gap-toothed stage. Asking her to smile with her mouth closed solved her embarrassment and she looks mischievous rather than awkward – appropriate for her age. In a thoroughly traditional portrait, the lesser catchlight in the eye would have been touched out (one catchlight is the old rule) but both catchlights have been left for a more modern look.

**THE EYES
HAVE IT**

Even though the bond of affection is two-directional, you can often get the best results by making either the parent or the child the center of attention; focus on the one's clear affection for the other. Often, this may mean that one person looks at the other, who makes eye contact with the camera.

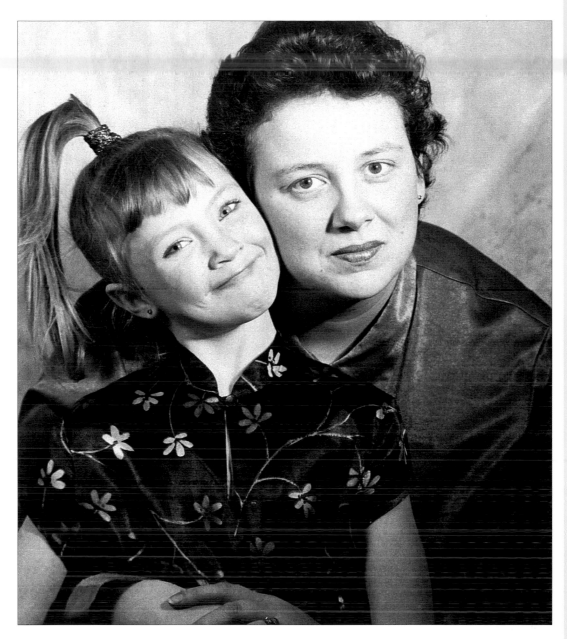

250 W-s fill flash in white shoot-through umbrella

250 W-s key flash with silver bounce umbrella

Group Portraits

OR FORMAL GROUP portraits, the Victorians have seldom been bettered. Most of them worked out of doors, because group portraits need a lot of studio space and a lot of light. Best, therefore, to choose an outdoor background related to the group (a school frontage, a sports field, whatever) and to shoot on a bright but not glaringly sunny day, using a powerful studio flash close to the camera as a fill, much like on-camera flash. The larger the format, the better − getting detail in a large number of faces from a 35mm image can involve excessive enlargement.

The best informal portraits often involve physical contact between the various members of the group; this works very well for parents and children. In the studio, you can use normal 9-foot (1.5-meter) backdrops, but you still need plenty of space behind the subject (12 feet/2 meters or more) to avoid shadows on the wall − hiring a large hall may be a good idea. Lighting needs to be broad, soft, and generous: one or two big soft boxes, and at least 1200 W-s of flash, will be necessary. Tungsten is often too harsh and rarely gives enough power. If it is powerful enough, it may well overheat the subjects.

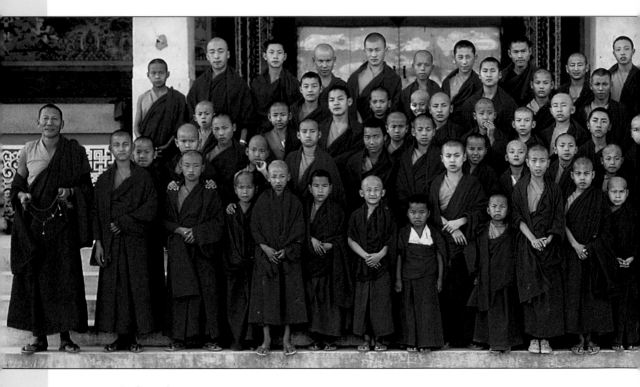

Young monks (ABOVE)

This is a classic school shot, in both good and bad ways. One boy has a big dressing on his face; a couple of wrist watches are far too obvious; and definition, even on 6x7cm, is marginal. But everyone is in, everyone is recognizable, and by posing them in the shade the problems of screwed-up eyes were avoided. A warming (81-series) filter would have improved the color somewhat; but this is on Ektachrome 64, a notoriously blue film. The boys are exiles from Chinese-occupied Tibet, living in India. Exposure: $1/125$ seconds at f/5.6 on ISO 100 color film (Kodak Ektachrome 64).

Family (RIGHT)
Backdrop: Fabric.

Lighting: One large soft box to camera left; very large, gold reflector to camera right; snooted spot as background light.

Exposure: f/11 on ISO 160 color negative film.

Problems and problem solving: Before the subjects arrived, it took half an hour to get the shaped light on the background right. For the final shot, an assistant held the gold reflector to camera right, angling it according to instructions in order to get the light precisely where it was needed. During printing, the lower part of the picture was burned in to accentuate the Rembrandt effect.

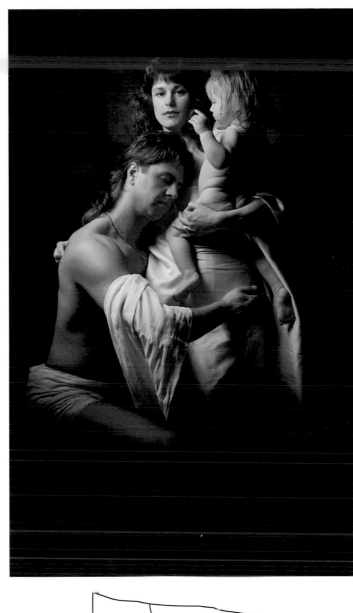

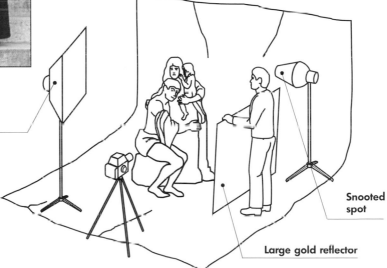

1200 W-s flash in soft box

Snooted spot

Large gold reflector

Pets

WE HAVE ALL seen superb pet studies: fluffy cats, noble dogs, even parrots with their glowing colors. The trouble is, they are almost unbelievably difficult to shoot on a regular basis; most good pet studies by non-specialists involve a very large dose of luck.

Flash is normally desirable; the glare of tungsten will make many animals uncomfortable, though some cats may bask in its warmth. With cats, a well-fed animal will be more cooperative than one that is hungry (in so far as cats are ever cooperative) and patient photographers may well get one of those wonderful teeth-baring yawns if they feed the cat, stroke it while it goes to sleep,

place it on a photogenic backdrop (such as a comfortable sofa), and wait for it to wake up.

Puppies will also be easiest to photograph when well fed, and a familiar background (a basket, a piece of blanket) will help to keep them in one place. Only a very obedient adult dog can normally be "directed."

The techniques of lighting pet portraits are surprisingly similar to those for lighting human portraits: soft light to emphasize cuddliness and innocence in kittens and puppies, and hard light to emphasize character such as a stalwart mien in dogs or ferocity in cats. Although sleeping poses are often good, it is as well to wait for the eyes to open or the animal may simply look dead.

Cat (LEFT)
A single tungsten light to camera left; an unusually cooperative kitten, before it got bored with the whole game; and lightning-fast reflexes. This was all that was needed for this cat portrait. The camera was a Rolleiflex TLR, which allows continuous viewing during the exposure: focusing was by moving the whole camera to and fro, which is generally the easiest approach. The near-silence of a Rollei TLR is less likely to alarm an animal than a noisy SLR. Exposure: $1/30$ second at f/5.6 on ISO 125 film (Ilford FP4).

Dog (ABOVE)

Subject: West Highland white terrier.

Lighting: Two flash heads in standard reflectors; the key (to camera left) is closer to the subject than the fill (to camera right).

Exposure: f/8 on ISO 100 film (Agfa R100S).

Problems and problem solving: The dog's owner is to camera right, comforting the dog. The "crown" is a part of a fire screen and adds a touch of whimsy. Slight underexposure holds texture in the fur while preserving the richness of the surroundings. It took 20 frames to get four or five good shots.

FUR AND FUR LIGHTS

Dark fur "eats" light and has a very long tonal range; generous exposure (at least one stop over, sometimes more) is essential, and black and white is often more successful than color. Light fur is much like any high-key subject (see page 122) A powerful light in a soft box, lighting obliquely, is probably easiest as well as best; a backlight (a fur light, like a hair light) can be very effective if you can manage it.

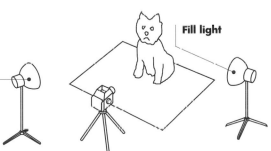

Key light

Fill light

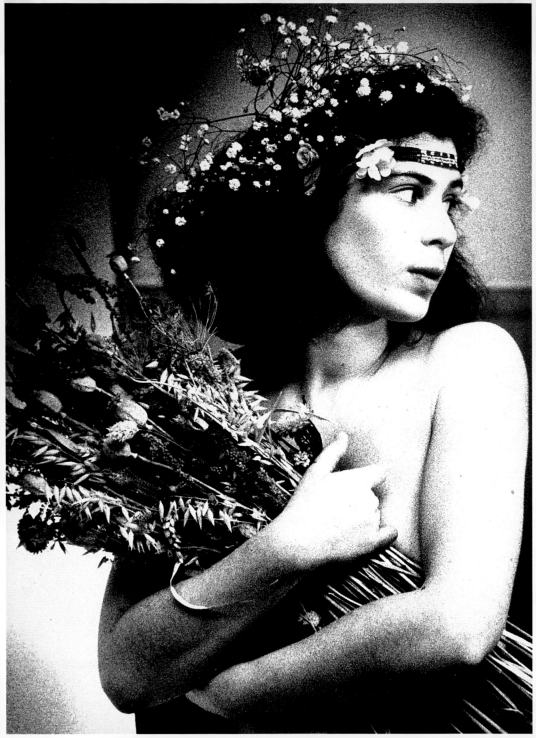

The Gentle Nude

NUDES WERE ONE of the first subjects on which photographers turned their lenses – scarcely surprising in view of the long tradition of the nude in other arts. Some people can be upset by nudity, but all save the most prudish will find certain types of nude photograph attractive, as long as the picture is not too explicit.

Because of the infinite variety of the human body and the human face, simplicity is generally the key to the most attractive nudes. A single light is often all that is needed, and an excess of sophistication can destroy the impression of innocence and freedom that is central to what we have called the gentle nude. High-key lighting (see page 122) is normally appropriate, without strong chiaroscuro, and (as with so much Victorian photography) it is possible for technical shortcomings to add to a picture, rather than detract from it. A single light, set more or less level with the subject's eye-line, can create an impression of morning sun, long a favorite light of painters; backgrounds should be uncluttered, but not featureless.

CLOTHES AND COMFORT

Remind your model not to wear tight underwear before the shoot: marks from elastic can take hours to fade. Also, remember their comfort: the studio must be warm enough for the model and they could bring a warm, soft dressing gown to wear between shots. A clean, soft blanket is a good idea too.

Ophelia (LEFT)
Props: Fresh and dried flowers.

Lighting: Tungsten: key is 500W in 12-in (30-cm) reflector to camera right, fill, more distant 500W in 12-in (30-cm) reflector to camera left.

Exposure: $1/125$ second at f/4 on ISO 400 film (Ilford HP5 Plus).

Print: Orwo monochrome paper, grade 5, sepia-toned.

Problems and problem solving:
As the light was not very strong, the aperture had to be stopped down slightly for a reasonable depth of field, and a fairly short shutter speed had to used because the camera was hand-held. This made a fast film imperative – but the grain enhances the picture. The grain is further emphasized by printing on very hard paper.

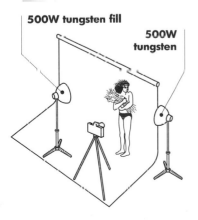

500W tungsten fill

500W tungsten

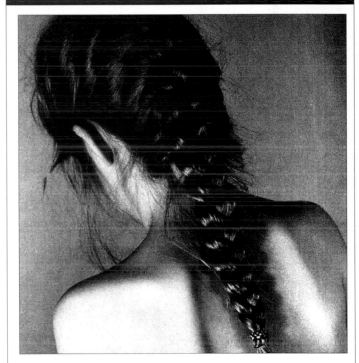

RELATED IDEAS: ARMADILLO

The pose of the model in "Ophelia" is hardly immodest. If you can avoid showing those areas that are normally concealed from the public gaze, most people will find nudes attractive. Back views, such as "Armadillo" here, are even less of a problem. The whimsical title comes from the shape of the hair; lighting was a single 500W Argaphot lamp in a 12-in (30-cm) reflector. Exposure: $1/30$ second at f/8 on ISO 400 film (Ilfor HP5 Plus).

PROJECTS

The Dramatic Nude

THE DRAMATIC NUDE tends to excite strong feelings, for or against. A common reaction from the more liberally inclined is that while they do not necessarily like a given picture, the photographer should have an absolute right to produce it.

Unlike the "gentle nude" described on the previous pages, the dramatic nude may well be lit dramatically – low-key lighting is often used. Very often, a single light is all that is required, or (at most) a key and a fill. The real technique lies in the choice of props and surroundings.

Drapes can be of muslin, which should be well washed for softness and to make it handle properly, or of builders' dropcloths

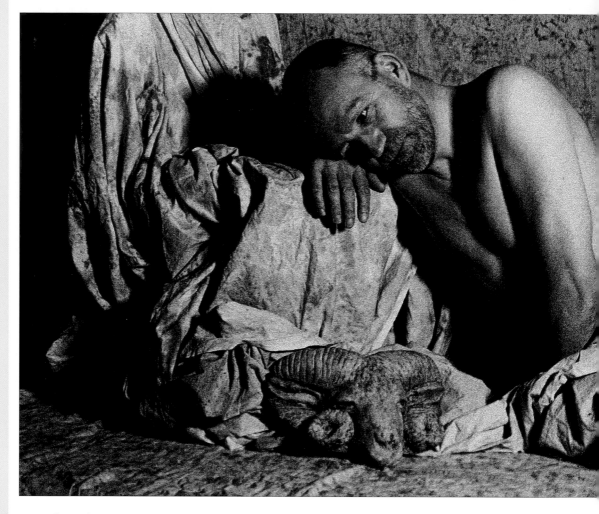

Nude (ABOVE)

Props: Chair; stone ram's head).

Background: Home-made backdrop (see page 82).

Lighting: One 250 W-s flash head to camera right, at about the eye-level of the subject.

Exposure: f/8 on ISO 200 film (Paterson Acupan).

Problems and problem solving: Inspiration for this shot came from from the Victorians: simple props, simple lighting, and a drape across the model's hips. The model distances himself from the viewer by looking away, concentrating attention on form and mood, rather than personality.

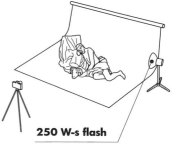

250 W-s flash

as used for home-made backgrounds (see page 80). Props can be sourced almost anywhere, but good hunting grounds include architectural salvage yards, garden centers, junk shops, and local auctions.

Another common feature of dramatic nudes is the exploitation of a particular aspect of the photographic process, such as the pearly gradation of a beautifully processed roll-film or large-format image, or the harshness and grain of a "pushed" 35mm film rated at well above its normal speed.

RELATED IDEAS: ALL IN THE MIND

You can create disturbing effects almost accidentally. The blurred head and feet are partly caused by differential focus, but are more a consequence of the "center spot" screen used in front of the lens. The lingerie is modest enough – but the photograph is both memorable and somewhat threatening because of the way in which attention is focused on the stocking-tops and flowered panties, and the way it looks as if the model is tied up (in fact, the photographer's instructions were merely, "Try sitting on your hands and leaning backward"). The key light is a 500W Argaphot from the right; a second 500W Argaphot, further away at camera left, provided the fill. We thought long and hard about including this picture, but eventually decided to do so. Exposure: $1/30$ second at f/4 on ISO 400 film (Ilford HP5 Plus).

NUDES AND PRIVACY

Models need privacy both from other people and from the photographer. Unless they are out-and-out exhibitionists, few will appreciate an audience of hangers-on, so windows may need to be masked with translucent film and doors may need to be locked. Also, the model is there to model in the nude, not to do a strip-tease – provide somewhere private for him or her to dress and undress.

Architecture

House Interiors

Small Interiors

House Interiors

A NY SORT OF interior photography involves two or three balancing acts. The first is between getting enough into shot, while still looking natural. The second is between retaining the normal ambience of the place, and getting enough light (and light that is even enough). The third, in many cases, is balancing interior lighting against exterior.

Ultra-wide lenses not only "stretch" perspective unnaturally, they also make it difficult to get the lights where you want them. They also tend to darken the corners of the image. It is often better to use, for example, a 24mm or 21mm on 35mm, rather than a 17mm or 14mm.

The importance of ambience is obvious, but in truth, many rooms are extremely unevenly lit, so they record on film as pools of light in blackness. Your main problem, therefore, lies in balancing out the light, as much as ensuring you have enough of it. There are two main ways of doing this. One is to use directional lights, lightening areas at a distance, the other is to use small, concealed non-directional lights to lighten the area immediately around them. Crossed shadows are sometimes inevitable, but the trick is to keep the lighting soft enough that it is not obtrusive.

The question of balancing interior light against exterior is covered on page 152.

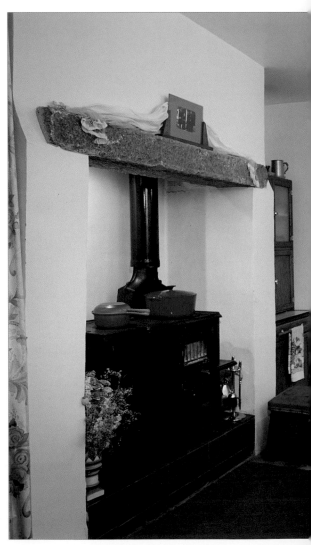

Kitchen (RIGHT)
Location: Kitchen, approximately 12 x 14 feet (3.5 x 4 meters). The aim was to create a warm, welcoming atmosphere.

Lighting: Available window light; available domestic light; firelight; one 150 W-s head, bounced off the wall; one 1200 W-s head, snooted and honeycombed.

Exposure: 4 seconds at f/16 on ISO 100 color film (Fuji Astia).

Problems and problem solving: Without additional lighting, the lower right-hand part of the picture and the stove were very dark. The bounced light solved the problem, with the light warmed by the yellow paint, but getting a tight enough snooted spot onto the stove required considerable improvisation with a honeycomb jury-rigged in front of a snoot. The table looked rather bare and had to be "dressed"; the kitchen door had to be open (or it was a featureless area) but not too open (or the untidy hall was revealed); and the vase of flowers was needed to break up the dark area to the left of the stove.

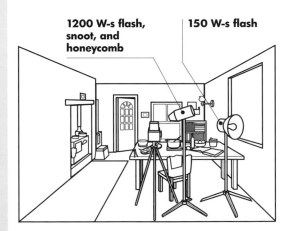

1200 W-s flash, snoot, and honeycomb 150 W-s flash

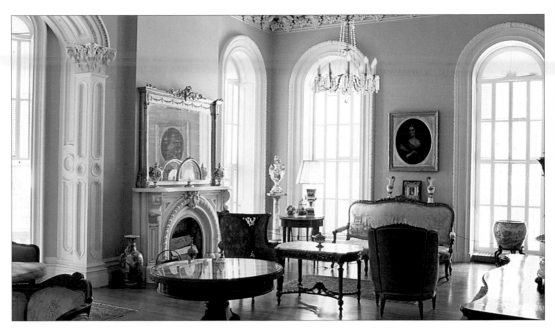

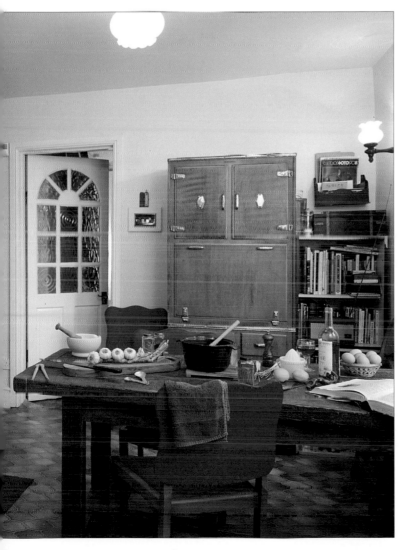

Interior, Sturdivant House
(ABOVE)

With a predominantly light-colored interior, you can often get away without any artificial lighting at all – if you choose the right time of day and (if necessary) make wise use of shutters and curtains. This early 19th-century house in Selma, Alabama, was shot using only available light. This also makes it easier to use extreme wide angles, in this case a 14mm lens. Exposure: 1 second at f/16 on ISO 100 film (Fuji RDP).

Small Interiors

THERE ARE TWO big problems with really cramped and inaccessible interiors. One is getting the light even, without harshness, and the other is choosing the right focal length. The temptation is always to use the widest available lens, but this can lead to difficulties with leveling and perspective. The latter can be a real problem in a confined space, and the wider the lens, the more careful you have to be.

On the bright side – literally – you do not normally need very powerful lights. Flash is a much better bet than hot lights: it is easier to diffuse, less likely to overheat the work area, and there is much less risk of burning yourself on the lights themselves. The secret is to keep the light reasonably diffuse, which can be difficult in a confined space. Bounce the light off a convenient white surface or reflector, or diffuse it

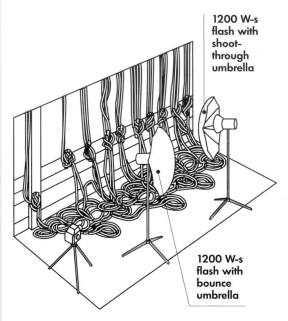

1200 W-s flash with shoot-through umbrella

1200 W-s flash with bounce umbrella

Catwalk of fly loft, Theatre Royal (RIGHT)
Location: A fly loft is the area above the stage from which scenery is "flown." The catwalk is about 6¹/2 feet (2 meters) wide and 16¹/4 feet (5 meters) long.

Lighting: Two 1200 W-s flashes, one with diffuser umbrella, the other with shoot-through umbrella.

Exposure: f/22 on ISO 100 film (Ilford Delta).

Problems and problem solving: The biggest problem was carrying all the necessary lights and camera equipment up the precipitous steps to the fly loft. After that, the main difficulty lay in getting lighting that was adequately even, without being boringly flat. The lights had to be hard against the wall, so the room to maneuver was limited. A 47mm lens on 6x7cm (roughly equivalent to 21mm on 35mm) was adjudged the best compromise between looking natural and getting everything in.

through a white scrim, or just use a diffuser dome over the light.

With long, narrow interiors, you should not have a problem if you only want to show one end, but if you want to show much of one of the long walls you are likely to need two or more lights, well diffused, and carefully positioned to avoid unlit areas or overlaps (which will give hot spots).

Attic (ABOVE)

Access to the attic is via a tiny (40 x 50 in/90 x 130 cm) door some 8 feet (2.5 meters) above the ground. The photographer was balanced on a ladder, with the camera in the doorway; the tin trunk with the clothes in it was about 5 feet (1.5 meters) from the camera. The light was an 800W tungsten-halogen focusing spot to camera right, bounced off a sheet of white nylon taped to the wall; bouncing was the only way to get a (reasonably) diffuse light, and even with 800W, a very long exposure was necessary. Tungsten light on daylight film was used to create a warm, nostalgic glow; the picture was also shot on monochrome (for hand coloring) and on tungsten-balance light (which was less successful). Exposure: 8 seconds at f/11 on ISO 100 film (Fuji Astia).

PROJECTS

Large Interiors

With large interiors, it is almost impossible to overwhelm all the ambient light. Even if you could, it would seldom look convincing: a room is, after all, designed to be seen by normal lighting. Your main aim, therefore, should be to lighten dark areas while retaining as natural an ambience as possible. Mixed light sources (see page 20) are frequently a problem, and short of "gelling" each light, the best approach is either to shoot black-and-white film or to live with it.

Generally, daylight balance film works best: the warm yellow of tungsten against the neutral color of daylight and flash is normally more attractive than the cold blue of flash and daylight against neutral tungsten, which is what you would get with tungsten film.

Sheer power is the biggest problem in many cases; even with powerful flash units, you may end up shooting at f/5.6 or f/8. This is no problem with 35mm but with larger formats it can lead to severe depth-of-field problems.

Extreme wide-angle lenses allow you to frame a wide area but lead to problems with perspective and evenness of illumination; it is better to use a longer lens if you possibly can.

Theatre Royal, Margate
Lighting: Two 1200 W-s flash heads on the stage, on either side of the camera, plus ambient light.

Exposure: 10 seconds at f/8 on ISO 100 film (Fuji Reala).

Problems and problem solving: The theater is very high and narrow, with steeply raked seats, so a super-wide lens (14mm on 35mm) was the only option. A very high Benbo tripod (about 7 feet/2.1 meters) allowed a "square-on" picture without tilting the camera. With a big tripod, you need a stepladder. Negative film was chosen to allow subsequent manipulation in printing, if needed.

The landscape-format shot (main picture) was more successful than an attempt to show both the auditorium and its ornate ceiling in one picture (upper left). For the picture of the ceiling (upper right), two 1200 W-s flash units, pointing straight up, allowed an exposure of f/8. A 14mm lens was used to put the ceiling in the context of the balcony; a 28mm lens would have been sufficient if the ceiling alone was to be recorded.

Auditorium and ceiling

Ceiling alone using vertical flash

MULTIPLE POPS

You will normally need long exposures even with flash, to allow the ambient light to record adequately. If your flash is not powerful enough to illuminate the whole subject in one "pop," you may find it easiest to work with "open flash." With, say, a 10-second exposure, you should be able to fire the flash manually two or even three times, recycling times set the limits. If your camera allows multiple exposures, you can of course shoot, say, four, two-second exposures with synchronized flash each time. The big risk is camera movement between shots.

1200 W-s flash

1200 W-s flash

Exteriors

THE BEST ADVICE for lighting exteriors is, "Don't even try." You need a lot of light, and unless you use multiple sources, the results often look like flat cut-outs, with inky shadows and washed-out highlights and not much in between.

The usual approach for "night" shots is to shoot at twilight when there is still some light in the sky. Another possibility is to shoot by the light of a full moon. Or if there are floodlights or other lights, you can wait for these to be switched on.

Flash is a possibility, if you use very fast film (ISO 1000 and above), reasonably fast lenses (preferably f/2 or faster) and a powerful flash unit, though washed-out foregrounds are a major risk. If the flash is not powerful enough from the camera position, carry the flash nearer the subject and work with an assistant, or use two or more flash guns. For still more power, consider big bulb flash units (see page 48). If there is a power socket within range (with an extension cable if necessary), you can use studio electronic flash or continuous lighting; for that matter, generators can sometimes be hired from firms catering to the building trade.

EXPOSURE DETERMINATION

For extra sensitivity, remove the incident light attachment, point the meter cell at the flash (or at the moon) and give 5 times the exposure indicated. Bracket generously, allowing for reciprocity failure (see page 26). Alternatively, remember that the light of the full moon is approximately one millionth of the power of sunlight, so use the "sunny f/16" rule ($1/_{ISO}$ speed at f/16) as your base exposure, and multiply it by 1,000,000.

Available light – full moon

On-camera flash

Off-camera flash (LEFT)

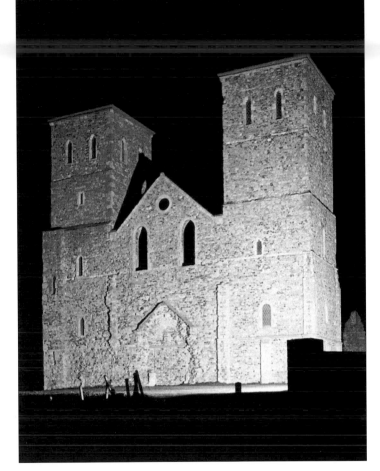

Full moon and "painting"
with flashlight (BELOW)

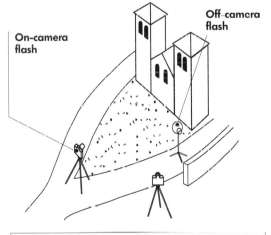

St Mary's, Reculver
Location: An abandoned 12th-century church.

Lighting:
On-camera flash (FAR LEFT): Metz 45 CT-1 165 feet
(50 meters) from the subject.
Exposure: f/2.8 on ISO 1600 film (Fuji Super HG)

Available light (LEFT): Full moon.
Exposure: 2 minutes at f/4 on ISO 1600 film (Fuji
Super HG): calculated as 1,000,000 x $^1/_{1600}$ second
at f/16, plus 1-$^1/_3$ stops for oblique lighting and
reciprocity failure.

Off-camera flash (ABOVE): MPP Micro-Flash with
PF100E bulb, 100 feet (30 meters) from the subject.
Exposure: f/4 on ISO 125 film (Ilford FP4)

Available light plus light painting (ABOVE RIGHT):
Full moon plus continuous painting with a flashlight.
Exposure: 4 minutes at f/4 on ISO 125 film (Ilford
FP4 Plus).

Problems and problem solving: It is always difficult
working on a cold, dark night. Dress warmly, and carry
a flashlight to see what you are doing. As you cannot
see much through the viewfinder, scale focus, or ask an
assistant to stand by the subject with a flashlight to
focus on. Note the star streaks (caused by the earth's
rotation) in the long exposures; the awkward shadow
and uneven lighting when using off-camera flash; and
the burned-out foreground with the on-camera flash.

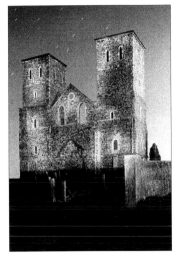

On-camera
flash

Off-camera
flash

"PAINTING" WITH LIGHT

To "paint" with flash, open the shutter and fire the
flash manually at different parts of the building. Shield
the lens between flashes. A similar technique can be
used with a powerful flashlight (torch) – a variant on
the studio technique seen on page 38. On a bright
moonlit night, the moonlight itself will register along
with your supplementary lighting.

PROJECTS

Windows and Light

THE TRADITIONAL WAY to record both the interior of a room and the view through the window was to make two exposures, one an hour or two before sunset, and the second an hour or two after. The first would record the scene through the window, the second (with appropriate lighting) the interior. This remains an excellent and economical way of doing things; but most people, photographers and building owners alike, cannot afford the time, and it is impractical if there are people in shot.

The usual modern alternative, therefore, is to use flash. Take care to avoid reflections from the windows; modeling lights are all but essential, and if you are using small slave lights without modeling lights, then Polaroid tests are indispensable.

If your outdoor reading is 1/60 second at f/16 – which it can easily be for a sunlit garden – then you need a powerful flash unit that will give you around f/11 on the subject. Generally, it is best if the interior looks slightly darker than the exterior, though if the exterior looks a little darker, people will simply assume it is twilight, or that it is winter outside. If your flash can only manage f/8, then switch to 1/125 second at f/11; the ambient light exposure will remain the same, but the flash exposure will be increased by one stop.

MULTIPLE POPS

If your flash is not powerful enough to match the outside light, you will need a solid tripod and a camera with a high synch speed and multiple-exposure capability. A lens that will stop well down is also useful. Suppose, for example, your readings are 1/30 at f/16 (outside, daylight) and f/8 (inside, flash). Set the camera to f/22, and the shutter to 1/125. Make four exposures, waiting for the flash to recycle each time. Your cumulative exterior exposure is 4 x 1/125 second = 0.032 seconds, very close to .033 seconds or 1/30. You need four flashes at f/16 because this is the equivalent of two at f/11 or one at f/8 (the metered exposure).

Stained glass (ABOVE)

Many people have difficulty in shooting stained-glass windows, though actually they are quite easy. All you need is a reading of the window (or of a substantial part of it), preferably with a hand-held meter or integrating through-lens meter; multi-sector meters may "compensate" unpredictably. The important thing is not to include the surroundings, which will result in a bias towards overexposure (as will machine printing – you really need hand prints if you are shooting negatives). Then move back, compose, and shoot. If you need to light the inside, balance the flash exposure to the metered window exposure, taking care to avoid flashback from the window. This window commemorates a young couple killed in a motorcycle accident in 1931. Exposure: 1 second at f/16 on ISO 100 color film (Fuji Astia).

Combining indoor and outdoor light (BELOW)
Location: Kitchen.

Lighting: Daylight (outside), 1200 W-s flash, bounced off wall and ceiling (inside).

Exposure: $1/4$ second at f/16 on ISO 50 film (Fuji Velvia).

Problems and problem solving: Flashback from the window was the biggest single problem; it was overcome solely by careful positioning of the flash. The reading outside (on a winter's afternoon) was $1/4$ second at f/16; the flash was balanced to match this exactly. The total subject brightness range, from the sky to the black of the calendar, was 1000:1 without flash – too great for any color film to capture. Without fill flash, using only available light, you can just about see the objects on the table by the window. When using both flash and a long exposure to compensate for outside light, remember that subjects that are lit by both will receive more light than subjects lit with one alone. By changing the shutter speed to $1/500$ second (it was a leaf shutter and synched at all speeds) the effect of lighting only the interior can be seen. The weak gray-blue of the sky is accentuated by severe underexposure.

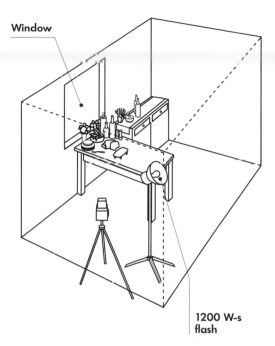

Window

1200 W-s flash

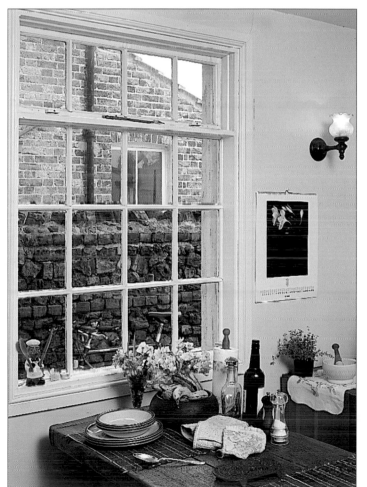

Available light and fill flash combined

Available light only

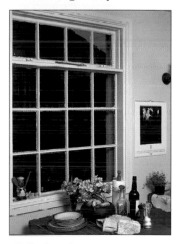

Fill flash only

Suggested Lighting Kits

The following is the advice that we wish we had been given when we first started to build up a collection of lighting equipment. You may well need to modify it in light of your particular needs, but what follows is a good starting point.

One immutable piece of advice is, however, to avoid photofloods. They offer only a very limited range of reflectors; the heat build-up is terrific; the bulbs are infuriatingly (and expensively) short-lived; and they will generally do more to put you off lighting than they will to encourage you to use it creatively. "Hundred-hour" lamps are only a little more expensive to buy, last far longer, and can be fitted to a much wider range of more modern equipment. Another strong recommendation is to be very wary of cheap, secondhand amateur lighting that was flimsy when it was new and that will rarely have improved with age.

HOW BIG A KIT?

Realistically, the only limits on building a flash kit are what you can afford, and what you have room for. You can almost always find not just a use, but a need, for yet another light, light modifier, or accessory. Much the same is true of tungsten, but with three additional considerations. The first is heat build-up. The second is the fact that you cannot turn the lights up and down in the same way that you can with flash – you have to use lamps of different powers, or move them closer to or further from the subject. The third is whether or not the power circuits available can handle more than a few kilowatts.

You can, however, do a great deal with a single lamp – even a builder's lamp (see page 40) – especially if it is supplemented with a couple of bounces. Add a second lamp, and you can control your fill instead of relying on spill and bounces. And in general, a three-light outfit will do all that any amateur requires, as well as sufficing for most professional applications. Whether you choose flash or tungsten, the amount of power you need will depend both on what you shoot, and on what formats you use. For 35mm portraits, which are normally shot at wide apertures, you do not need much

power at all; as long as the ambient light does not overwhelm the added lights, you have all you need. For large-format close-ups, shooting at marked apertures of f/32 and below (and even smaller effective apertures because of the extra camera extension), you need a lot of power.

SUPER-ECONOMY TUNGSTEN KIT

2 x 500W builders' lights, with stands
2 home-made bounces/diffusers (see page 56) at least 4 feet (1.2 meters) square
2 cheap, used "wobble-pod" tripods to support bounces

For increased versatility, build
1 trough with sockets for up to 12 domestic bulbs.

And add
2 clip-on "wander-lead" type lamps, with integral-reflector bulbs as sold for domestic "spotlight" fittings. Like the trough, these will only be suitable for black-and-white photography, because the light will be warm and reddish, even on tungsten film.

GENERAL-PURPOSE TUNGSTEN KIT

2 Interfit or similar holders for 500W "hundred-hour" bulbs
2 standard reflectors
2 tungsten-to-daylight lighting gels
4 lightweight lighting stands (for lights and bounces)
2 bounces/diffusers, home-made or from Lastolite or similar

As, and when, you can afford it, add:
1 "bowl and spoon" reflector
1 broad reflector
1 additional bulb holder (or, of course, more)
1 additional lighting stand (again, or more)
1 umbrella (shoot-through)
1 umbrella (reflector)

TUNGSTEN-HALOGEN/PROFESSIONAL TUNGSTEN KIT

2 x 600–1000W focusing spots with barn doors
2 tungsten-to-daylight lighting gels
4 lightweight lighting stands (for lights and bounces)

2 bounces/diffusers
1 big diffuser/bounce such as a Scrim Jim
1 scrim frame and set of scrims

As, and when, you can afford it, add more
600–1000W focusing spots with barn doors
and stands, and as many reflectors and diffusers
of various sizes as you can get. Also look out for
used professional lighting, especially "inky
dinkies" and 1K and 2K focusing spots. You may
also find 1K floods on the used market.

ECONOMY FLASH KIT

1 x 150–300 W-s flash
1 x 75–150 W-s flash
1 umbrella (shoot-through)
1 umbrella (reflector)
2 lightweight lighting stands (for lights and
 bounces)
1 flash meter
1 bounce (or more)

As, and when, you can afford it, buy more
powerful flash units to upgrade your economy kit
to a general-purpose kit, as described below.

GENERAL-PURPOSE FLASH KIT

2 x 600 W-s or more powerful flashes
1 umbrella (shoot-through)
1 umbrella (reflector)
1 lightweight lighting stand
1 heavy-duty lighting stand (better still, two)
1 flash meter
1 bounce (or more)

As, and when, you can afford it, add:
1 soft box
1 boom arm
1 set of barn doors (better still, two sets)
1 snoot
1 narrow-angle grid
1 scrim frame and set of scrims (again, two is
 better)

Additional flash units, both more and less
powerful, will never come amiss.

MANUFACTURERS' LIGHTING KITS

Lighting kits of various kinds are available
from a number of manufacturers, and
generally represent a significant saving over
buying the component parts individually.
The basic kit used in this book was a 1200
W-s Courtenay Solapro kit (two lights, two
stands, two umbrellas, synch lead, flash
meter). Like most kits, it was supplied with a
carrying case, which can be invaluable if you
are working on location. Plan your buying
strategy carefully so that accessories such as
snoots, grids, soft boxes, and so forth are fully
interchangeable. Buying from a single

manufacturer should also ensure that
modeling lights are genuinely proportional
to flash output, which is fairly unlikely to be
the case if you buy flash units from a number
of different manufacturers. On the subject of
compatibility, it is worth adding that the
(admittedly low-powered) Courtenay Interfit
flash system is cross-compatible with Interfit
tungsten lighting, so reflectors, umbrellas,
etc., are all interchangeable. This allows an
easy transition from a general-purpose
tungsten kit to an economy flash kit; and
there is also a useful degree of compatibility
between Interfit and the more powerful
Solapro line-up.

OTHER ACCESSORIES

Whatever lighting you decide upon, we
strongly advise you to make some form of
background system your highest priority.
You will also do well to buy a roll of black
aluminum foil (see page 58); some duct
tape; a number of strong-jawed clips; a few
large sheets of cardboard, black on one side
and white on the other; a box of polystyrene
roofing tiles; some florists' wire; some white
fiberglass curtain material (to make
heatproof diffusers for hot lights); and a
Swiss Army knife. With these accessories you
can set up an astonishing variety of lighting
equipment.

BACKGROUNDS

1 background support system,
 bought or improvised
1 roll white seamless paper
1 or more fabric backdrops, bought or
 home-made (see page 82)
1 piece black velvet, at least 40 x 80 in
 (100 x 200 cm)

As, and when, you can afford it, add other
backgrounds, both seamless and fabric.

Glossary

As well as the terms used in the book, a number of other common usages are included. As mentioned elsewhere, terminology in lighting is far from standardized.

Acetate – Modern name for GEL; the material from which "gel" filters are now made.

Acrylic – Shiny, flexible plastic "glass" sheeting; may be transparent, opal, colored, black, or silvered like a mirror.

Argaphot – Trade name for leading HUNDRED-HOUR BULB.

Available light – The general light level, before photographic lights are added (page 32).

Barn doors – Movable FLAGS attached to a light (page 60).

Beauty light – (1) Diagonal KEY light casting a distinct nose shadow. (2) Another name for a BOWL AND SPOON.

Bounce – Surface to reflect or (more rarely) absorb light (page 56).

Bowl and spoon – Large reflector with a diffuser cap over the light source itself (page 60).

Brute – Powerful, TUNGSTEN lamp.

Bulb flash – Old-fashioned flash with expendable flash bulbs (page 48).

CC filters – see COLOR-CORRECTION FILTERS.

Chiaroscuro – Literally "light/shadow" (from the Italian). The use of light and shade. See also REMBRANDT LIGHTING.

Cold light – (1) Bluish light; light of high COLOR TEMPERATURE. (2) CONTINUOUS LIGHT SOURCE generating significantly less heat than TUNGSTEN.

Colorama – Trade name for leading brand of seamless paper.

Color-correction filters – Camera filters made in additive (red, green, blue) and subtractive (cyan, magenta, yellow) primary colors, in a wide range of strengths, for making fine adjustments to image color (page 18).

Color temperature – A measure of the color of a light source (page 18).

Continuous light sources – Lights that stay on continuously, as distinct from FLASH (pages 34–43).

Contrast – (1) Subject brightness range: a contrasty subject has extremes of light and dark, a flat subject is in closer shades of gray. (2) Image brightness range: a contrasty image is usually lacking in mid-tones and is made up of dark shadows and bright highlights, while a flat image is dull and lacks sparkle. (3) Lens contrast: a contrasty lens does not degrade shadows and veil the image, but a flat lens does.

Cookie – see GOBO.

CT – Short for COLOR TEMPERATURE; also the name for some GELS.

Daylight – One of a range of "white" lights that records on film like daylight. The COLOR TEMPERATURE range of daylight varies quite widely. Blue-dipped "daylight" bulbs are of limited use in photographic lighting but are invaluable for evaluating print colors.

Diffuser – Translucent panel interposed between a light and a subject to soften the light (page 56).

Duct tape – Broad, very sticky fabric tape, usually silver or black. Name now used interchangeably with "gaffer tape."

Effects light – A light directed at a particular feature in a picture, such as hair or jewelry, without affecting overall exposure (page 24).

Expendable flash – See BULB FLASH.

Feathering – Using just the edge of the pool of illumination cast by a lamp, usually to get a soft effect.

Fill – The light(s) that fill the shadows not illuminated by the KEY light.

Flag/French flag – Opaque panel used to shield the subject) or camera) from the direct rays of a light (page 58).

Flare – (1) Degradation of shadows, or introduction of reflections, caused by light reflected inside a lens or camera. (2) Bright reflection off a highlight.

Flash – Brief light. Usually an electronic discharge tube that can be re-used repeatedly, but may also be expendable (see BULB) or even pyrotechnic (see MAGNESIUM).

Flat – (1) A large BOUNCE. (2) Lacking in CONTRAST.

Flicker-free – High-frequency FLUORESCENT light (page 48).

Flock – Paper covered with microscopic non-reflective bristles, to give a dead matte, velvet-like surface.

Flood, floodlight – Lamp throwing a broad, substantially uncontrolled beam of light (page 40).

Fluorescent – Continuous gas discharge lamp, including flicker-free (page 48). May vary from sickly green to a good approximation to DAYLIGHT (page 49).

Focusing spot – A SPOT where the relative positions of the bulb and reflector, or bulb and focusing lens, can be varied to control the spread of the light.

Foil – (1) Another name for a GEL; an abbreviation for "lighting foil." (2) Black foil used for light control, (page 58).

Front projection – A means of projecting a background onto a highly reflective screen (page 39).

Gaffer systems – Miniature scaffolding systems that allow you to hold reflectors, flags, subjects, cameras, and more in position.

Gel – Originally short for "gelatine." (1) A colored foil used to modify the color of a light, now usually made of acetate. (2) A thin, flexible camera filter, which may still be made of gelatine. Most COLOR-CORRECTION FILTERS are still gels.

Gobo – Perforated FLAG (page 58), though some use it as a synonymous term for flag. Another name for a cookie. See also PROJECTION SPOT.

Grad – Graduated filter, clear at one end and tinted or gray at the other.

Gray card – Card with precise 18 percent "mid-tone" reflectivity and neutral color balance (page 78).

Grid – Another name for a HONEYCOMB.

High key – Picture with predominantly light tones, though not necessarily lacking in small areas of dark tones including pure black (page 122).

HMI – flicker-free "cold" light source (page 48).

Honeycomb – Grid that makes light from a flash (or other source) more directional, like a SPOT rather than a FLOOD (page 62).

Hot light – TUNGSTEN lamp.

Hundred-hour bulb – Relatively long-lived bulb delivering high light intensity at 3200K (page 40).

Incident-light metering – Measuring the light falling on, rather than the reflected from the subject (page 70).

Inky or **inky dinky –** Small TUNGSTEN SPOT, normally 250W. Often used as an EFFECTS light.

Joules – Another name for WATT-SECONDS.

K (kiloWatts) – One kiloWatt is 1000 WATTS. Big TUNGSTEN lamps are usually referred to as "2K," "5K," etc.

Key – The main light; the one that casts the shadows (page 24).

Light brush – An enclosed light source to which is attached a flexible "light pipe," which allows the photographer to direct the light as if he or she were "painting" with it (page 48). Can be approximated with a flashlight (page 152).

Lighting ratio – The ratio between the KEY and FILL lights (page 24).

Low key – Picture with predominantly dark tones, though not necessarily lacking in areas of light tones, including pure white (page 125).

Lucite – Trade name for leading brand of ACRYLIC sheeting.

Magnesium – Highly flammable metal, burning with a brilliant flame and clouds of dense white smoke. Formerly used in the form of ribbon, or powdered in flash powder.

Monobloc – FLASH head with built-in power supply (page 46).

Morris lamp – Small SLAVE lamp that screws into a domestic socket.

Northlight – Another name for a SOFT BOX.

Penumbra – The soft edge to a shadow, as distinct from the darker inner portion or umbra.

Perspex – Trade name for leading brand of ACRYLIC sheeting.

Photoflood – TUNGSTEN lamp delivering a great deal of light at 3400K, but with a correspondingly short life (page 40).

Photo-pearl – Another name for HUNDRED-HOUR lamps.

"Pops" – Flashes. "Multiple pops" compensate for lack of power.

Projection spot – SPOT that can cast an image, like a slide projector. The image for projection may be from film or (for durability and heat resistance) of perforated metal, in which case it is often called a GOBO.

Pup – Modest professional TUNGSTEN lamp, normally 500W.

Reciprocity failure – Very long or very short exposure times may require additional exposure, a "failure" of the normal law that you can compensate for changes in light intensity by changing the exposure time. Color films may also require additional filtration (page 26).

Reflector – (1) The casing surrounding a light source, which reflects the light onto the subject. (2) Another name for a BOUNCE.

Ring flash – Flash where the discharge tubes are concentric with the lens, to allow shadowless lighting (page 48).

Scrim – Fabric that reduces a light's intensity. May also act as a DIFFUSER.

Seamless (paper) – Wide rolls of paper, used as background material (page 82).

Slave – A flash light that fires when another flash is fired. The response is sufficiently rapid that the flash is effectively instantaneous (page 44).

Snoot – Tubular or conical attachment to control the spread of light from a lamp (page 62).

Soft box – Large, diffuse light, usually with electronic flash as the light source (page 64).

Specular reflections – Strictly, reflections, as in a speculum or mirror, which cannot be controlled by the use of a polarizing filter. In popular usage, any highlight that "burns out" to a pure white because of FLARE.

Spill – Light that "spills" from the main sources. Sometimes it can be used as general illumination or FILL; at other times it needs to be controlled with FLAGS and SPILL KILLS.

Spill kill – Small REFLECTOR that blocks off the sideways SPILL from a light source (page 60).

Spot, spotlight – Highly directional light source (page 42).

Strip – Long, narrow light source, resembling a stretched SOFT BOX.

Sweep – Continuous background, typically of seamless paper but also of fabric, tracing film, etc.

Trough – Large, shallow, box-like TUNGSTEN light source containing several bulbs (page 42).

Tungsten – CONTINUOUS, HOT lighting produced by heating tungsten filaments electrically. Conventional electric lamps are, of course, tungsten (pages 34–43).

Umbrella – Collapsible umbrella-shaped BOUNCE or DIFFUSER (page 64).

Watts – A measure of electrical power (page 42).

Watt-seconds – A measure of flash power (page 46).

Window-light – (1) The light from a window. (2) Another name for a SOFT BOX.

Index

Acknowledgments

Without the help of the following people, this book might never have appeared; or at the very least, it would have been considerably less comprehensive and well illustrated.

Paterson Group International supplied both flash and tungsten lights, which were used to light the majority of pictures in the book and appear in a number of pictures themselves. Paterson also supplied several excellent Gossen meters, as well as their own FM3 flash meter.

Lastolite supplied a wide range of bounces and flags; their Collapsible Scrim System and Tri-Flector, in particular, were invaluable. Lastolite also supplied lens shades and lens filters from the Cromatek range.

Minolta's Spotmeter F proved to be an unbeatable and easy-to-use meter and we are grateful for the loan of it. Visual Pursuits, a branch of Brandess Kalt Aetna, provided a number of very useful lighting filters including large polarizing filters. Lee filters were also extremely helpful and supplied a number of lighting filters.

For materials, we are indebted to Pat Wallace of Polaroid for instant picture materials; to Fuji, for generous supplies of Astia, which came out as we started this book; and (once again) to Paterson Group International, for Acupan 200 and 800 film and processing chemistry.

Among individual photographers, our greatest thanks must be to Marie Muscat King, whose pictures appear throughout the book. In particular, they are on pages 44 (Child), 47 (Ken), 66 (Birefringence), 72 (Laura), 85 (Hat), 94 (Still Life), 95 (Christmas), 121 (Monsieur Muscat), 124 (Karen), 125 ("Metamorphosis"), 132 (Karen and Rachel), 138 ("Ophelia"), 139 ("Armadillo"), 140 ("Caligula") and 140 (Nude).

K of K Studios in Bolton kindly supplied two pictures, the family group on page 135 and the high-key portrait of her daughter Rebecca on page 122. Peter Read took the picture of the dog on page 137, facing Colin Glanfield's picture of a kitten on page 136. George Gardner's beautiful black-and-white study of jasmine flowers appears on page 97.

Other pictures are by the authors, and we would like to thank all those who have granted us access to fascinating places over the years, from the Tibetan Administration in exile to the Theatre Royal, Margate.

Finally, special thanks to our models. Sophie Muscat King was as indispensable to the book as her mother Marie. Mary, eponymous proprietor of the Woodman School of Dancing in Canterbury, arranged for us to photograph Emma, Julia, Laura, Rebecca and Sarah; we thank her and them. And we must not forget Harvey, who appears on page 110.